# the 3D art book

## Tristan Eaton

foreword by Carlo McCormick

PRESTEL

MUNICH · BERLIN · LONDON · NEW YORK

© Prestel Verlag, Munich · Berlin · London · New York, 2011
for the text, © by Tristan Eaton, 2011
for illustrations of works of art, © by the artists, 2011

Prestel, a member of Verlagsgruppe Random House GmbH

**Prestel Verlag**
Königinstrasse 9
80539 Munich
Tel. +49 (0)89 24 29 08-300
Fax +49 (0)89 24 29 08-335

**Prestel Publishing Ltd.**
4 Bloomsbury Place
London WC1A 2QA
Tel. +44 (0)20 7323-5004
Fax +44 (0)20 7636-8004

**Prestel Publishing**
900 Broadway, Suite 603
New York, NY 10003
Tel. +1 (212) 995-2720
Fax +1 (212) 995-2733
e-mail: sales@prestel-usa.com

*www.prestel.com*

Prestel books are available worldwide. Please contact your nearest
bookseller or one of the above addresses for information concerning
your local distributor.

Library of Congress Control Number: 2010939234

British Library Cataloguing-in-Publication Data: a catalogue record for
this book is available from the British Library. The Deutsche Bibliothek
holds a record of this publication in the Deutsche Nationalbibliografie;
detailed bibliographical data can be found under: http://dnb.d-nb.de

Editorial direction by Ali Gitlow
Design by Thunderdog Studios, Inc.
Additional 3D conversions by American Paper Optics, LLC
Production by The Production Department
Origination by GHP, West Haven, Connecticut
Printed and bound in China by Midas Printing International Ltd.

Verlagsgruppe Random House FSC-DEU-0100
Printed on 157 gsm Korean Neo FSC matt art paper

ISBN: 978-3-7913-4549-9

**The author wishes to thank:**

Jonathan R. Stein of The WillowDean Agency
Robert J. Zagula
Matthew Eaton
Paul Beresniewicz
Edward Chow
Andres Torres
Punyaruk Baingern
Phil Young

# contents

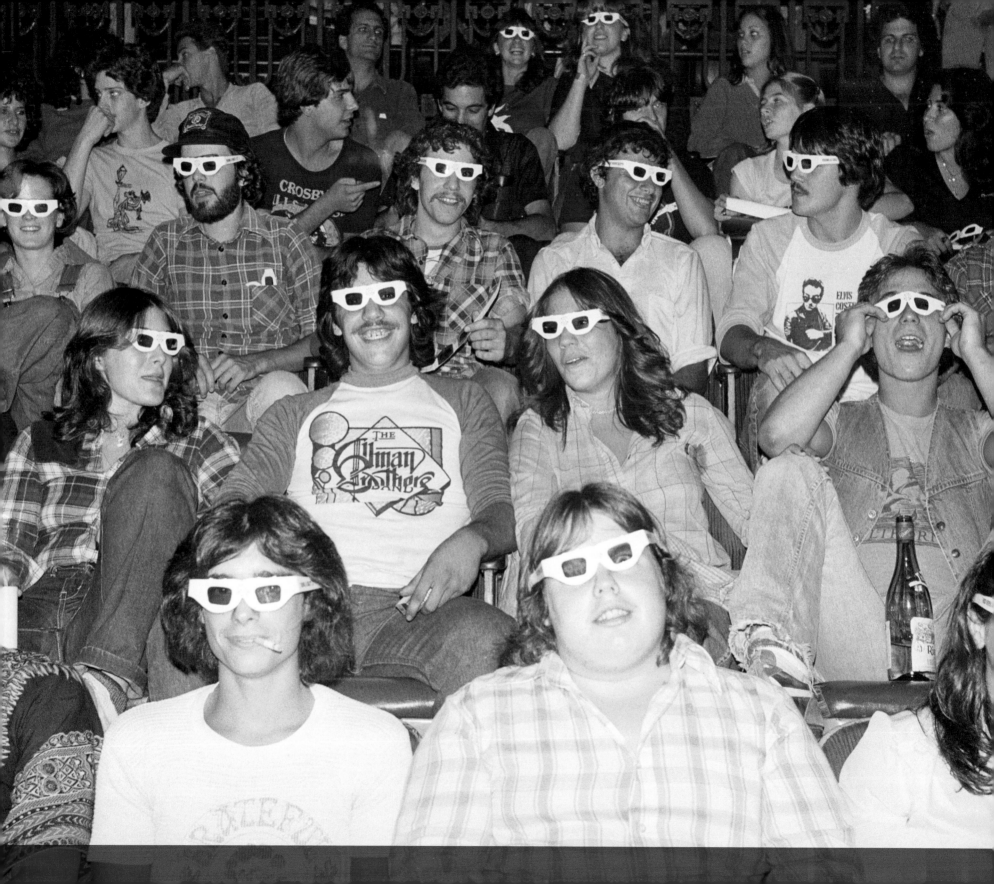

# foreword

## 3D: SEEING IS BELIEVING

The idea of viewing a flat picture—whether on a page, canvas, or screen—as something in three dimensions is a bit of a contradiction in terms. We only understand its dimensionality as a matter of language: visual language, in the case of the stick figure we regard as human, but as a matter of semiotics no more involved in terms of reading than, say, a red octagon with the letters "S-T-O-P" written on it in white. This may be obvious to point out, but it is still crucial that we understand the nature of this trope. Pictorial space and dimensionality are deceits we mutually agree upon, constructs of representation that rely not only on the artist's hand, but most crucially on the eye of the beholder. A picture of a nude, no matter how lifelike or seductive it may be, is not a figure you can wrap your arms around. If you could, it would be a sculpture, which (as we all know) is what you trip over when you step back to look at a painting. Our eyes can only be fooled so much, and preconditioned as they might be by now to read depth within the picture plane, our acceptance of these conventions as a kind of reality has as much to do with our desires as with the artist's intentions. Our capacity to read a picture as a window, then, is aesthetically comparable to the sublime way in which our eyes may choose to embrace that nude.

Three-dimensional pictures of the sort we are celebrating here are part of a long lineage, in which representation has tried to map the visible world by directly interfacing with the psychology and physiology of perception. Because this kind of 3D is of a particularly lowbrow and low tech strain, it is perhaps easy to dismiss the work as overly retro in its effects. It may also appear passé, in light of the optical advancements that 3D rendering and animation have enjoyed recently, with the benefits of full spectrum polarization and digital computer graphics. This array of innovations ranges from glasses popularized in the late 1980s that used the relative difference of the signal timing between our eyes to interpret lateral movement as depth (it's

OPPOSITE PAGE: Fans watching the Neil Young movie *Rust Never Sleeps* wearing 3D glasses, 1979 © Lynn Goldsmith/Corbis

called the Pulfrich effect; you'd remember it best from the much-ballyhooed Diet Coke Super Bowl halftime show in 1989), to ChromaDepth, LCD shutter glasses, parallax barriers, integral imaging, and any number of technological wonders we'd be hard-pressed to actually explain.

Since the pictures in this book employ a remarkably antique form of stereoscopy (called anaglyph), with red and blue lens glasses that enjoyed a brief but significant pop culture craze in the early 1950s, they evoke a patina of nostalgia but also seem somewhat inconsequential when stacked up against the latest 3D spectacles from Hollywood, or the advent of 3D television. If we take a moment, however, to consider the full history of experiments and entertainments in three-dimensionality, we might understand how these artworks belong to an extensive history of visual deceptions construed in the name of a greater perceptual truth.

# The problem of rendering and reading images in the third dimension has vexed scientists, artists, and philosophers for centuries.

What all three 3D systems may ultimately have in common is that they are widely regarded as novelties. However, the problem of rendering and reading images in the third dimension has vexed scientists, artists, and philosophers for centuries, involving myriad disciplines like mathematics, optics, geometry, physics, and psychology. If it feels a bit trivial holding a pair of paper glasses to look at two-color drawings right now, it is worth considering that artists continue to return to these issues in no small part because they have proven fundamental to the way we see and understand the world around us. A curious cul-de-sac off a far more trafficked avenue of ideas, the anaglyphs in this book bespeak both the many ways in which art has tried to bring realistic observation to our experience of the natural world and the complex epistemological crises that have been wrought by their reliance on illusion to do so.

To get from first and second dimensions of lines and planes to the conception of space depends upon a description of depth that we call perspective. Already being worked on by the ancient Greeks (like Euclid), long before it was realized in the early 15th century during the Italian Renaissance, Plato was describing the visual dynamics of perspective as "that weakness of the human mind on which the art of conjuring

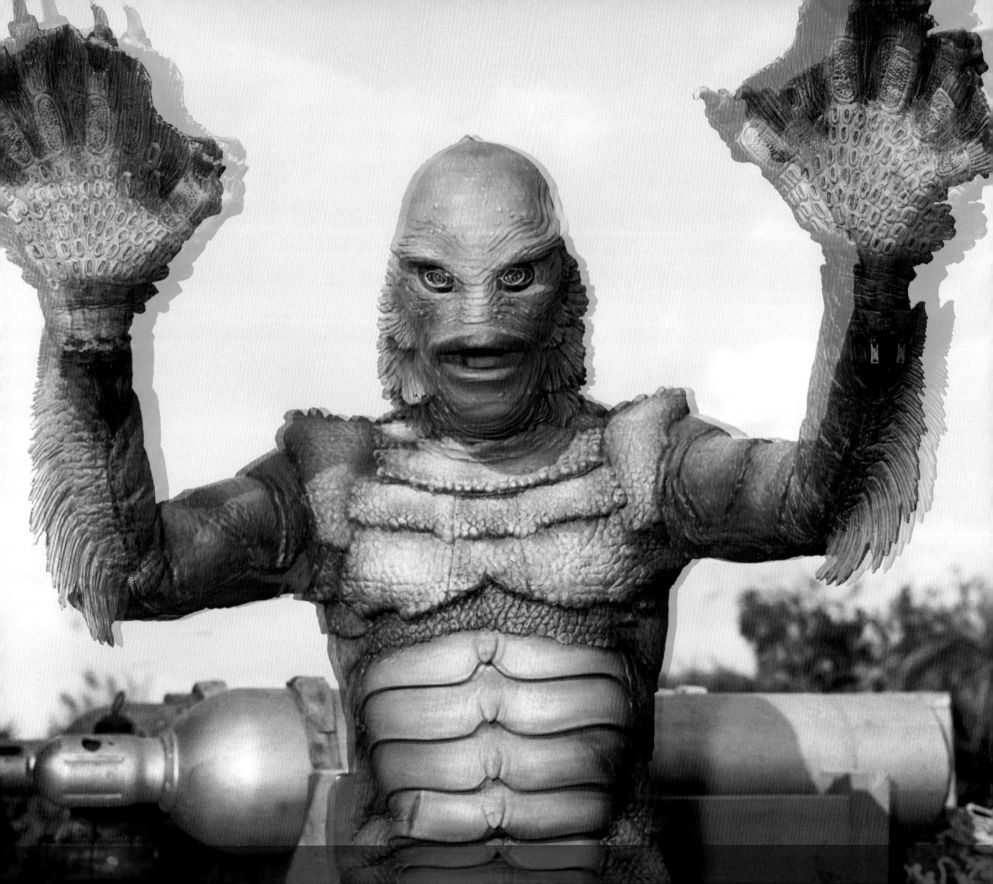

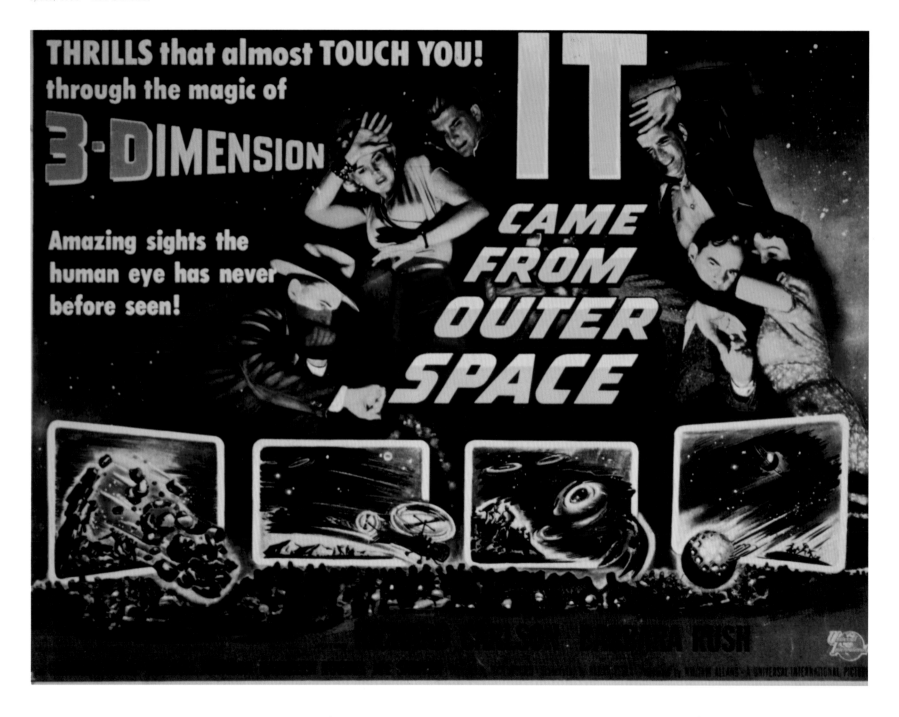

and deceiving by light and shadow and other ingenious devices." The consensus is that Raphael's genius is vested in his supreme mastery of Renaissance linear perspective as epitomized by his *School of Athens* mural, but Rene "I think, therefore I am" Descartes derided perspective as a lie, and Georges Braque railed "perspective is a ghastly mistake that has taken four centuries to address." We might just say that it is all a matter of perspective.

If one considers these complaints from the position of Descartes' rationalism or Braque's Cubism, their problem was not with space per se, but that one specific illusory way of conjuring it had become habituated as a single truth. While Descartes had little patience for the idea of a picture as a rational representation, he did in fact have a great fondness for the anamorphic art of the 16th and 17th century (anamorphosis being a distorted projection or perspective tangential to the main focal point of the work, in which the viewer would literally have to move to a particular vantage point to make sense of the image). The appeal here was that perspective could be seen not so much as a descriptor than as a metaphor, representing in most cases something spiritual beyond our normal range of perception or understanding.

Cubists like Braque, we might argue, presented a radical contradiction to the authority of linear perspective by supplanting its positioning of the viewer in a set place for the sake of realism with a cacophony of disparate perspectives based upon a shifting subjectivity. Perhaps that is why Picasso called a picture "a sum of destructions," and it is certainly why critic Leo Steinberg described this art as a "discontinuity at all levels of perception." This rupturing (through the anamorphic image or the Cubist picture plane) of the linear perspective that has so long been the mainstay of Western art begs a question of 3D art: by emphasizing and exaggerating depth through even more artificial pictorial means, is it overly beholden to our established notions of perspective, or rather, is it a subversive intervention against the normal way we see things? In some ways it is both, but to understand this, we need to know exactly how stereoscopic pictures work.

Devised by Sir Charles Wheatstone in 1838, the stereoscope was, like most any permutation of 3D that has emerged since then, based on an inherent glitch in human perception. Wheatstone was a prominent scientist and inventor of the Victorian era who would perfect an instrument for measuring electrical resistance (called the Wheatstone bridge), play a major role in the development of telegraphy, create a cipher widely used by the British forces in both world wars, and invent the English concertina. He based his seminal incursion into the world of three-dimensional imagery on how our perception of depth is created by the way our

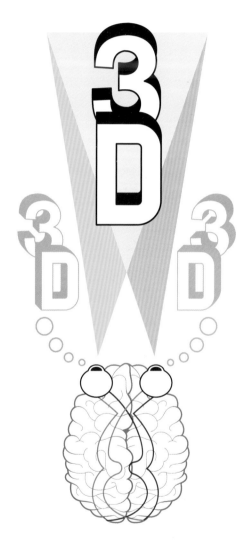

How we perceive 3D images

brain puts together an inherent disjunction in our vision. Because our eyes are separated by about two and a half inches, we view our surroundings with double perspective points. It is in the measure of this slight difference between what each eye sees that our sense of depth perception is created. In short, we have binocular vision. Wheatstone's stereoscope would become popular home entertainment at the turn of the century. Its obscurity to most of us today—like its vestigial presence in another bygone amusement, the View-Master—may set the tone for how our fascination with 3D pictures is at once faddishly temporal, yet remarkably persistent.

Hollywood produced its first stereoscopic movie, *The Power of Love,* in 1922 using a double-projector system, and sporadically dabbled in this novelty throughout the 1920s, 1930s, and even into the early 1940s. It wasn't until the success of the 1952 film *Bwana Devil* (which used Polaroid film's color separation process

## Our fascination with 3D pictures is at once faddishly temporal, yet remarkably persistent.

to produce the anaglyph imagery), that the extremely short-lived craze of 3D movies became legend. In 1953, audiences packed in to see these low-budget thrills, as major studios jumped into the fray. Columbia Pictures released *Man in the Dark* just days before the opening of Warner Brothers' Vincent Price vehicle *House of Wax*; these hits were followed by *It Came from Outer Space* (page 8) and *Creature from the Black Lagoon* (page 7), both from Universal Pictures. A year later, as suddenly as they captured our imagination, 3D movies all but disappeared from the pop culture landscape. Of particular relevance to the artists whose works are on display here was the nearly concurrent and equally brief phenomenon of 3D comics. Over a half-year period beginning in 1953 with the publication of *Three Dimension Comics* (featuring Mighty Mouse), they would draw on the talents of artists like Jack Kirby and Wally Wood, feature stars from Batman and Superman to Mickey Mouse and The Three Stooges, and infiltrate most of the dominant genres of the day.

What remains an unusual and revealing fact about both 3D film and comics, beyond their remarkably attenuated moments of glory, is that each was a desperate attempt to rescue their respective industries in a time of dire crisis. Hollywood was facing the dramatic effects of TV's popularity, as film attendance—which was at ninety million in 1948—had plummeted to a mere forty-eight million by 1951. The comics industry,

rutted between the peaks of its Golden and Silver Ages, was coming under increasing fire as the scapegoat for a new social woe called juvenile delinquency. The specter of Fredric Wertham's book condemning the medium, *Seduction of the Innocent*, proved damningly influential, and the eventual self-censorship of an industry-mandated comics code loomed on the horizon.

As much as people generally believe that any iteration of 3D can only be a fad that is doomed to fail, we have to ask ourselves what exactly these terms of failure are. Three-dimensional pictures may have yet to establish themselves as a sustained creative practice, but they have never gone away entirely, nor seemingly lost their latent potential to amaze. Their successes have, in their temporality, had lasting effects as devices which not only buoyed and sustained major forms of popular entertainment through difficult times, but more importantly short-wired our normative means of perception to a dramatic degree.

From the enigma of anamorphs like the floating skull in Hans Holbein the Younger's painting *The Ambassadors* to Wheatstone's stereoscope and stereoscopic photography, anaglyph drawings, 3D movies, animation, and television since then, the letting loose of analytic precepts regarding the nature of perception has had a volatile effect which has consistently produced the most outré of art. The some 100 anaglyphs collected in these pages belong to that bizarre and winding history of 3D representation not simply by virtue of their unruly content and preternatural effect, but because all these modes of expression are ultimately a kind of participatory art. In putting on the glasses we take part in the art, but not merely by matter of invitation—it is quite a necessity. As the proverbial falling tree in the woods, 3D art demands the presence of a viewer to achieve its dimensionality.

Aesthetics presumes that art is a conversation between the work and the contemplative gaze of its audience, but is it not really a three-way discourse between the work of art, the intentions of the artist, and how the viewer reads them? That is the discrete triumvirate of experience behind 3D art, its subtle but formidable connection to the vagueries of perceptual psychology, which makes it at once an active and activating practice. The artist's vision here, more self-conscious of its audience than ever, needs you and those damn silly glasses to be realized. Without the optical and physiognomic dynamics of perception by which we see things as being in space, this sleight of hand would be slight indeed. Without a device to separate, suppress, and then reintegrate our binocular vision, this must all look like a blurry batch of misregistered graphics. These pictures require your eyes to be truly trompe l'oeil. But like all great art, it needs to be seen to be believed as much as it needs to be believed to be seen. ▬▬

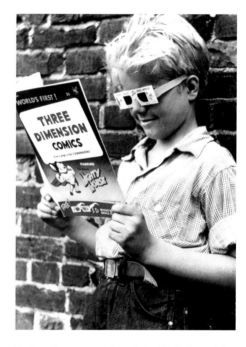

Wolfgang Routa, age 10, is enthralled by the latest fad—comic books in 3D, New York, 1953 ©Bettmann/Corbis

# introduction

TRISTAN EATON

I've been fascinated by art from the alternative, pop, and underground realms since I was a kid. Because my family moved around a lot, I experienced a tour of the best and worst graffiti, comics, advertising, and overall pop culture the world had to offer. Living in Los Angeles in the late 1970s and 1980s, London and Detroit in the 1990s, and New York in the 2000s, I was lucky to digest a varied and healthy diet of Terry Gilliam, *Akira*, *2000 AD*, *Style Wars*, Atari, and Powell Peralta. A weird mix of references for sure, but these vividly colorful, destructive images formed a mental tree house where Judge Dredd and Lance Mountain were my best friends. In the absence of a more traditional home base, this broad spectrum of cultural influences became my refuge. Perhaps that explains my obsession with outsider art? Or maybe I'm just genetically predisposed to spray paint and anime—who knows. What I do know is that I'm certainly not alone.

Around 1996, I became acquainted with a large group of artists who love the same strange art and culture that I do. As I got to know these people, it was obvious we had all been influenced by the same deviant art forms—we were outside insiders! There's a certain nostalgia for these early influences which you can see manifested in the art of my fellow outsiders. They all manage to beautifully warp their imaginations into a graphic display of reality gone wrong, celebrating everything from Saturday morning cartoons and graffiti to comic books, film, and politics. We all have to find our place in the world, and this type of art is ours.

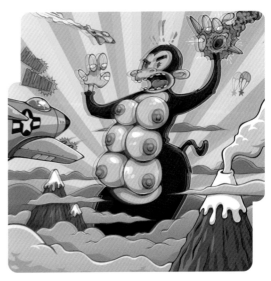

**ABOVE:** Tristan Eaton, *Monsters Have Issues Too*, digital, 24 x 24 in., 2004

**OPPOSITE PAGE:** Tristan Eaton, *Social Security*, acrylic on canvas, 48 x 48 in., 2003

The idea to collect work by this diverse group of artists in a book with 3D glasses didn't happen overnight, or at the whim of a publisher—far from it. *The 3D Art Book* is a four year labor of love accomplished with the help of my friends, coworkers and fellow artists. However, my personal love of stereoscopic 3D art goes back much further, which is probably where I should begin.

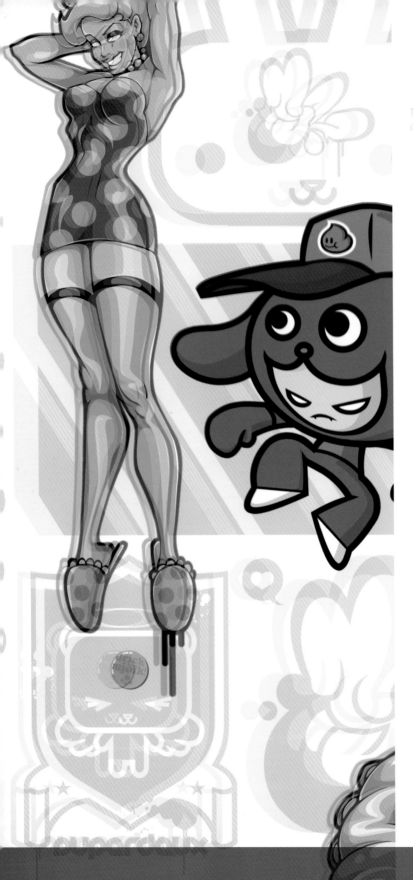

When I was 19 and living in Detroit, I worked at legendary silkscreen poster shop The Highway Press. While there, I was lucky enough to print work by many of my favorite artists and, on occasion, use the presses for my own half-baked projects after hours. My favorite of these projects happened to also be my first foray into 3D art, which was a total failure! Not being one to fail in any small way, I decided to silkscreen the piece four feet tall by four feet wide on the biggest press in the shop. Why not, right? I drew my image, then proceeded to manually make 3D separations, using a common sense approach to the technique. I moved the foreground to the left and the background to the right, and hoped for the translucent red-on-blue inks to produce the desired effect. This was in 1997, long before I used computers, so I cut the foreground and background shapes out of paper by hand and pasted them back together. Next, I produced 25 Duratrans films which I taped together to shoot a screen. One evening of sweaty printing later, and voila! I had a set of twenty giant 3D posters that didn't work at all. They looked pretty cool anyway though, and fostered my love of 3D art.

In New York a few years later, I finally figured out how to produce 3D art successfully, and continued to experiment with the technique as a hobby. In 2004, I was offered the chance to mount an exhibition at the now-defunct East Village gallery SOMA. I called the show *3-D Happy Action Fun,* and was thrilled to watch tipsy people, stoned and giggling, peering at the range of psychedelic works through 3D glasses.

My love of stereoscopic images was one thing, but what really brought this book about was a series of prints I made for the show. I had produced twenty solo pieces, and then realized how fun it might be to collaborate with some of my favorite artists on a few more (I've always loved collaboration, since it brings out the best in all

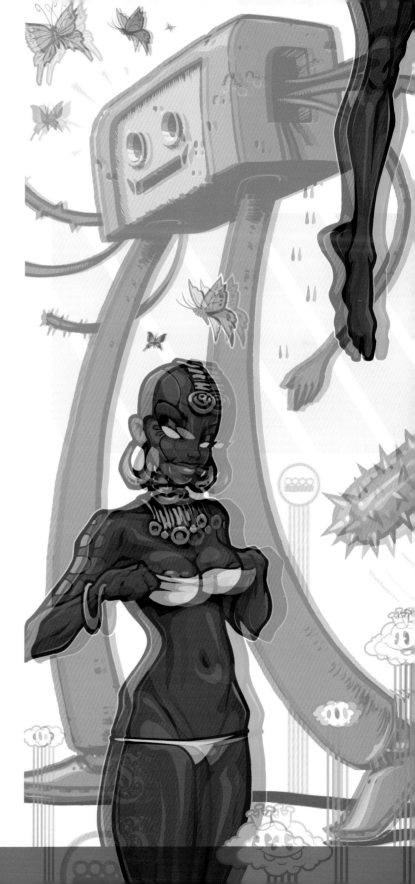

participants). I reached out to Filth, Jeff Soto, The London Police, and Superdeux, sending each a half-finished Adobe Illustrator file which we sent back and forth until the work was done. I then added the 3D effect, made an edition of each print, and was ecstatic with the outcome. I loved how, when you put on the glasses, a flat image could instantly become an environment where each layer floats in space, a graphic jungle of shapes.

Through 2009 and into 2010, I was fixated on the idea of recruiting other artists into the world of stereoscopic art. I was also convinced, way before the recent commercial success of 3D movies, that there is an audience for this type of experimentation, nostalgic though it may be. Using everything I'd learned from the 2004 show, I sent an invitation out to certain artists, and this is the final result.

Like-minded artists bounce images and ideas off of each other, refueling empty batteries and awakening dormant dreams. When you compare the artists in this book, you will see that we share nostalgia for the good old days of alternative art and pop culture; when you contrast us, you will see how each of us outsiders have re-envisioned these references in our own unique ways.

I hope this project serves as a portal into new worlds—not just the worlds depicted in the images, but into the artists' imaginations, our collective culture, and our shared visions. The reality we live in contains only three spatial dimensions, but surely there are more to consider. Time is one, but could imagination be another, a dimension where art does not fully exist until our minds collaborate? This book relies on the idea of collaboration; as a viewer, it must also include yours. I welcome you to put on the 3D glasses and join us in this strange and striking dimension. ■■ ■■

# It's time to put on your 3D glasses.

Todd Schorr
*Clowns and Crusaders, 2002*

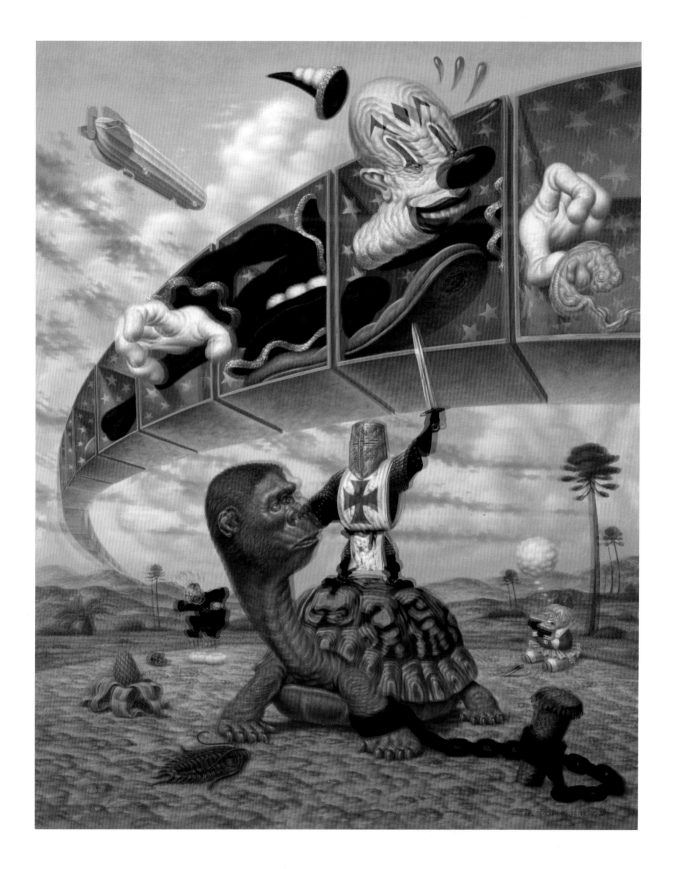

**Filth**

*Luxury Trim Deluxe, 2010*

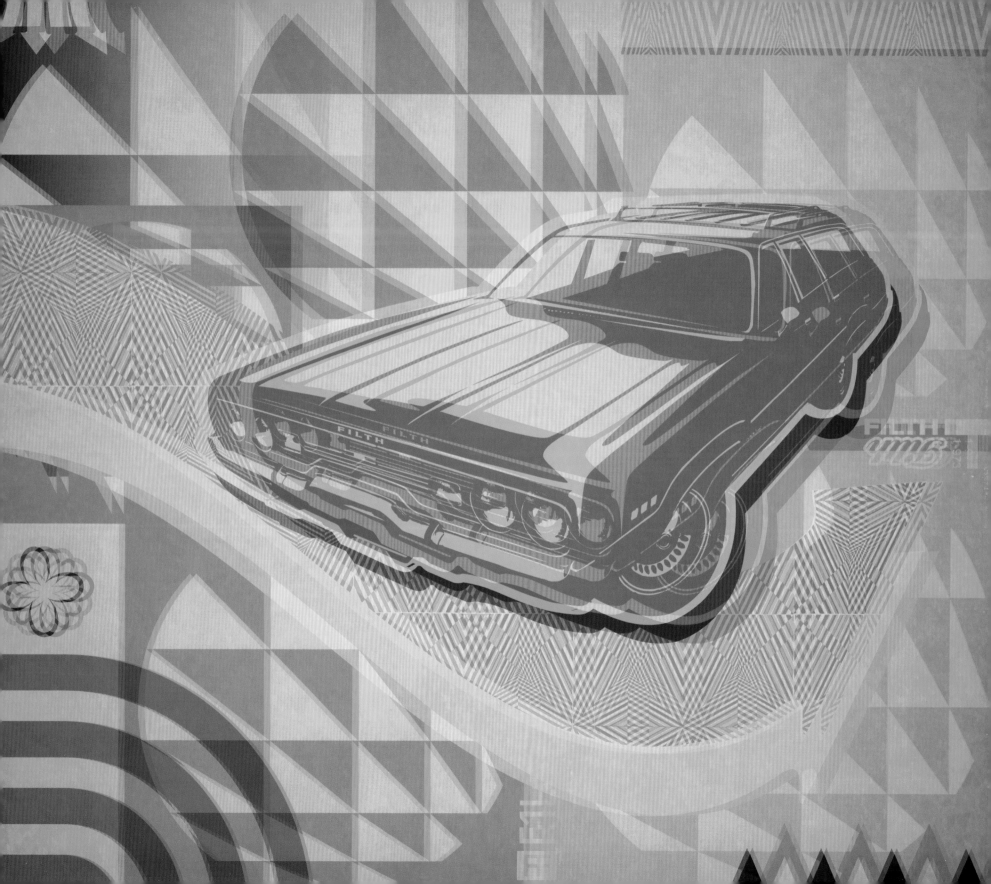

**Anthony Ausgang**
*The Mobius Striptease, 2010*

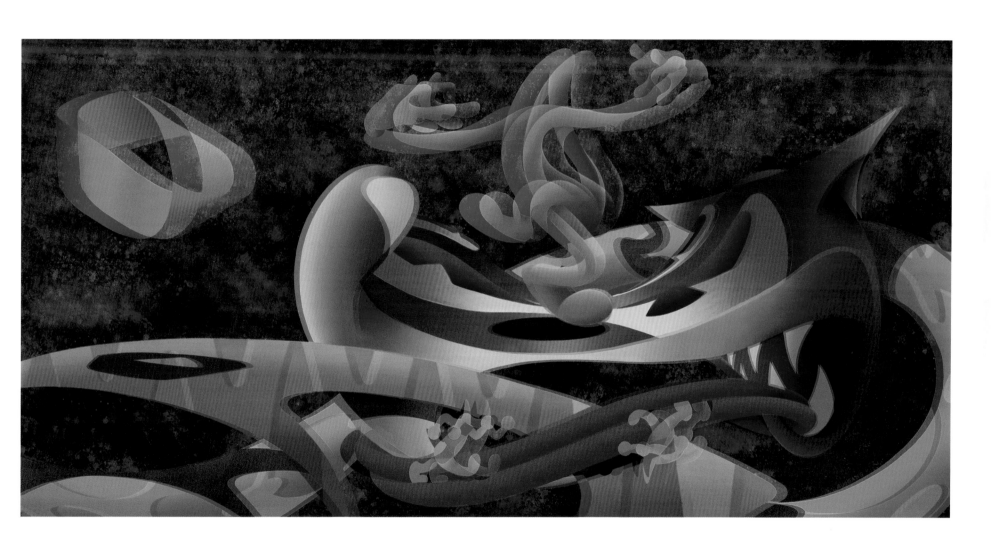

Glenn Barr
*Sibyls of the Valley,* 2008

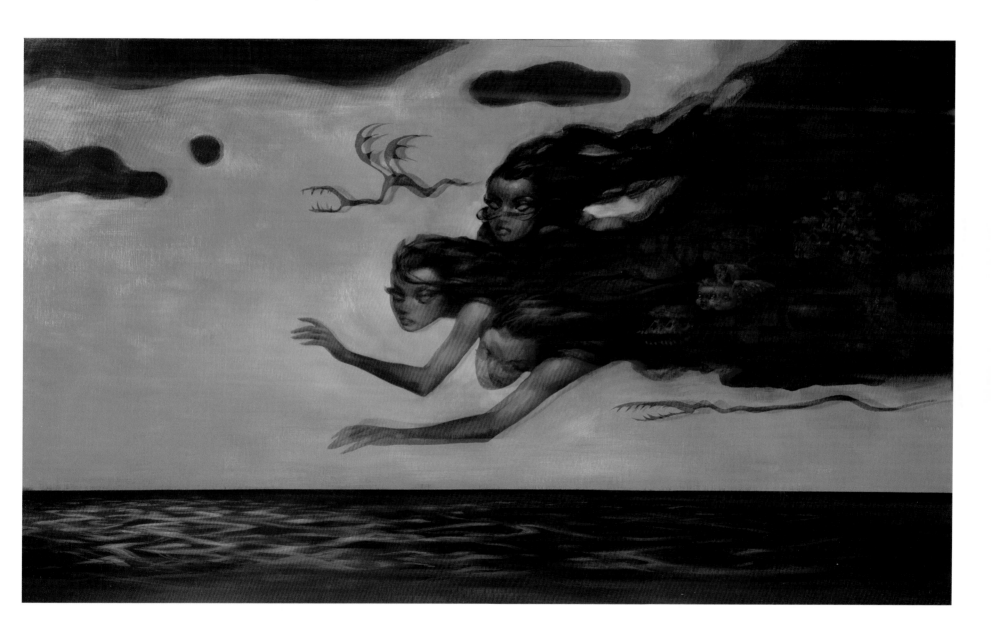

**Glenn Barr**
*Beckoning, 2008*

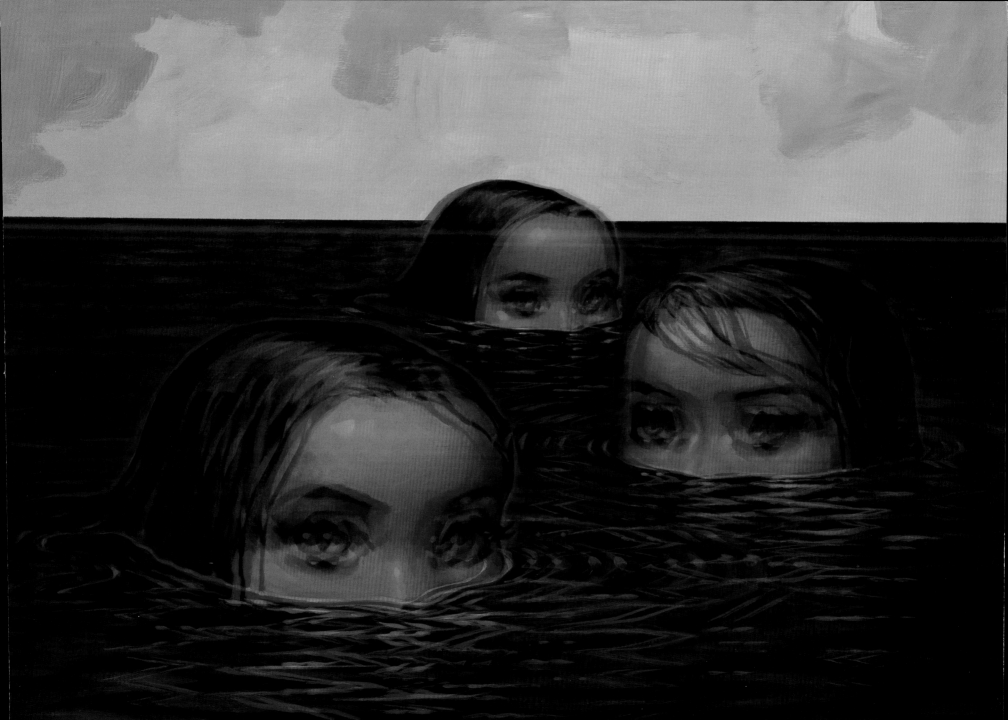

**Askew**

*Diamondism in Focus Part 1, 2010*

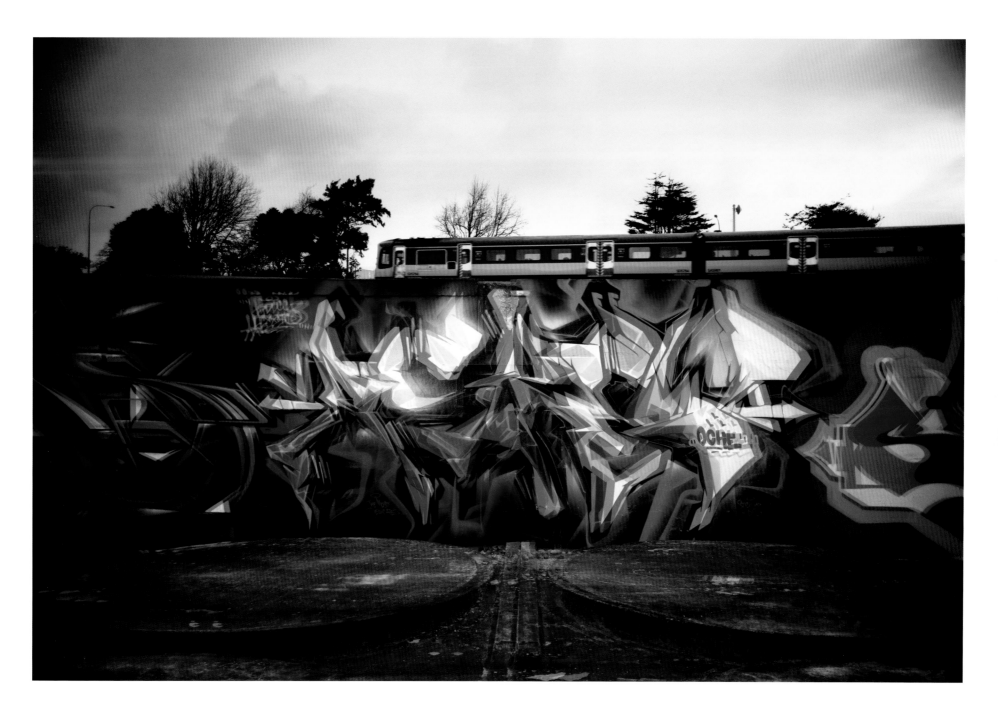

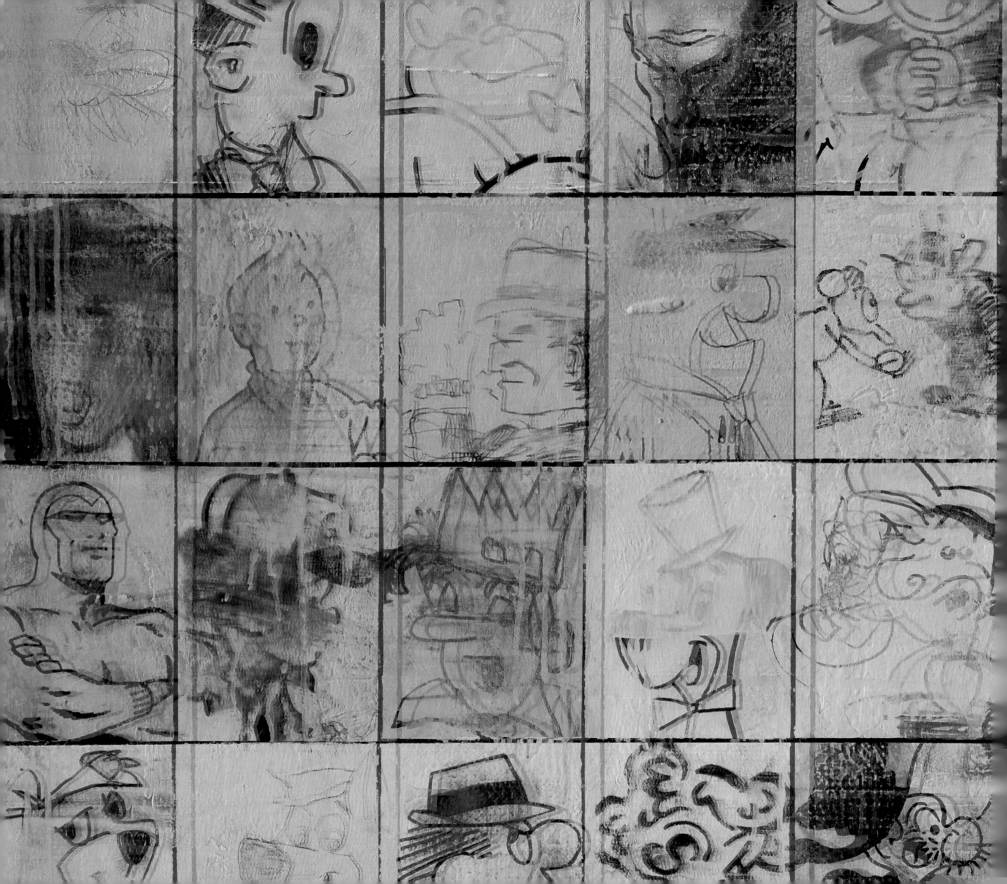

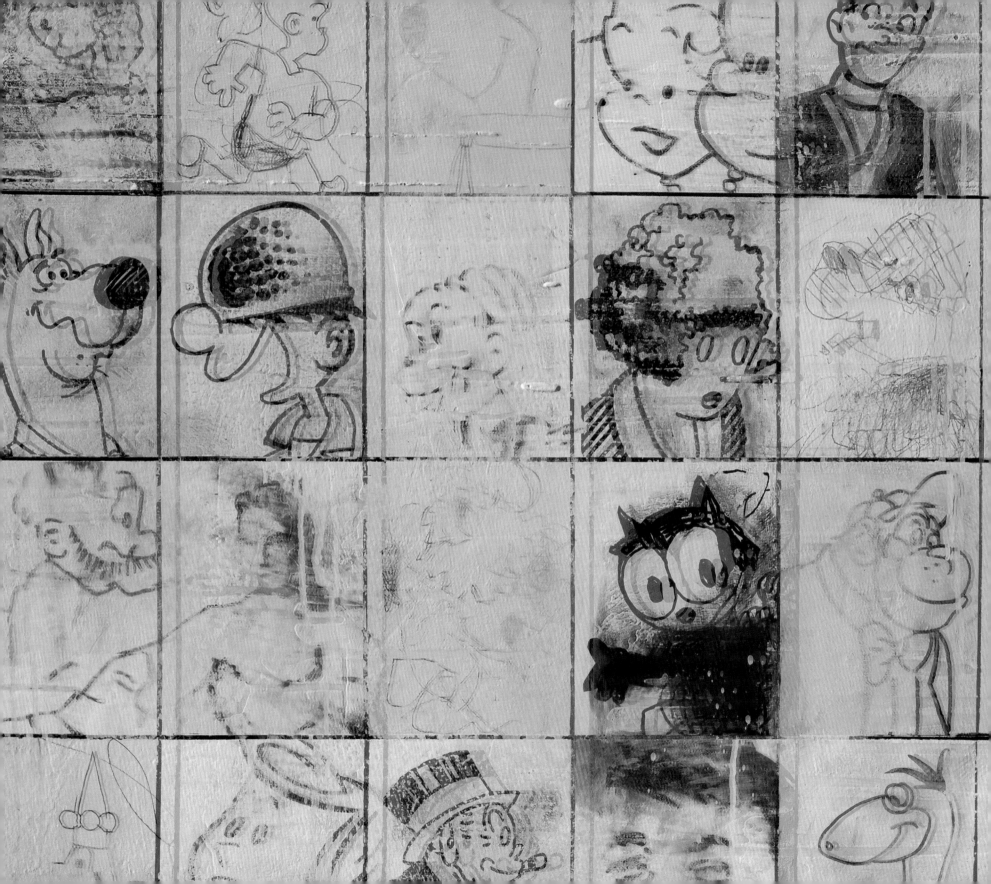

*previous spread:* **Bask**
*Draw 50 Famous Cartoons,* 2010

**Tom Thewes**
*DEMF (deLEKtrCITY),* 1999

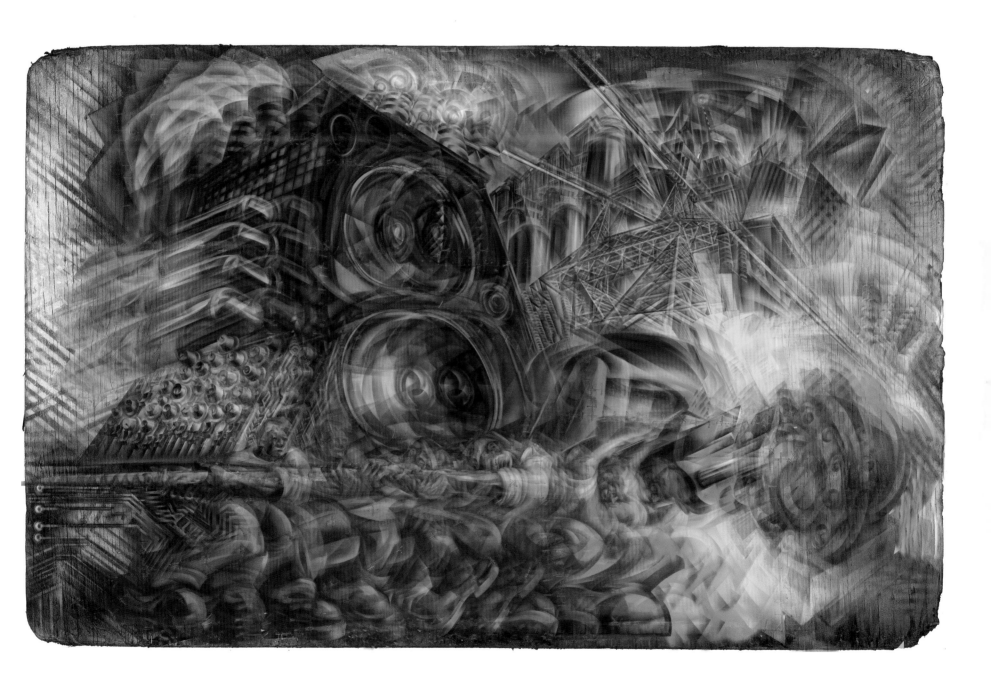

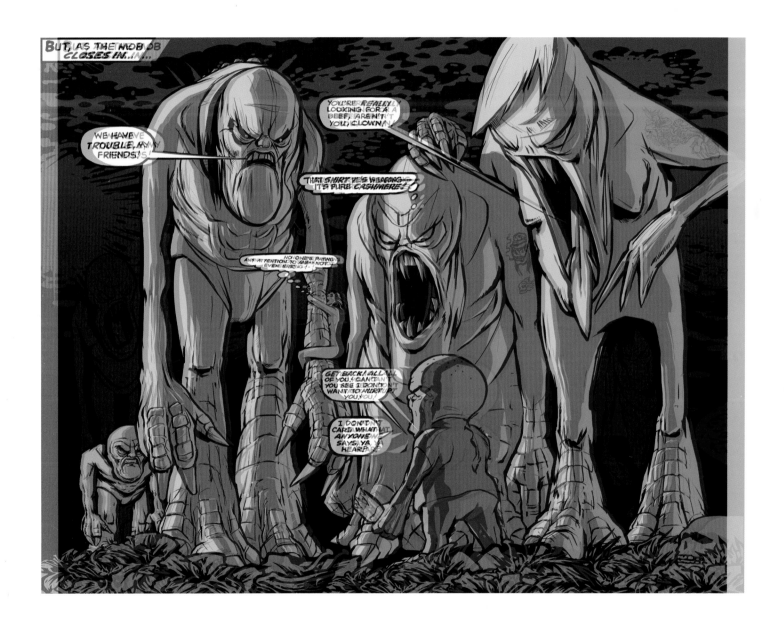

**Tes One**
*Flashing Lights,* 2009

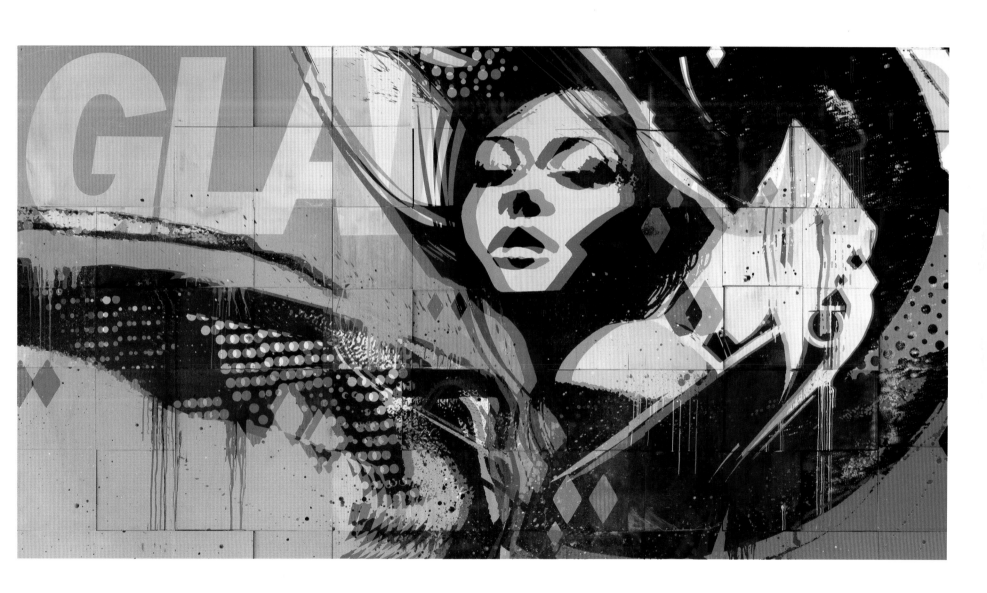

Gary Taxali
*Prixy,* 2010

40

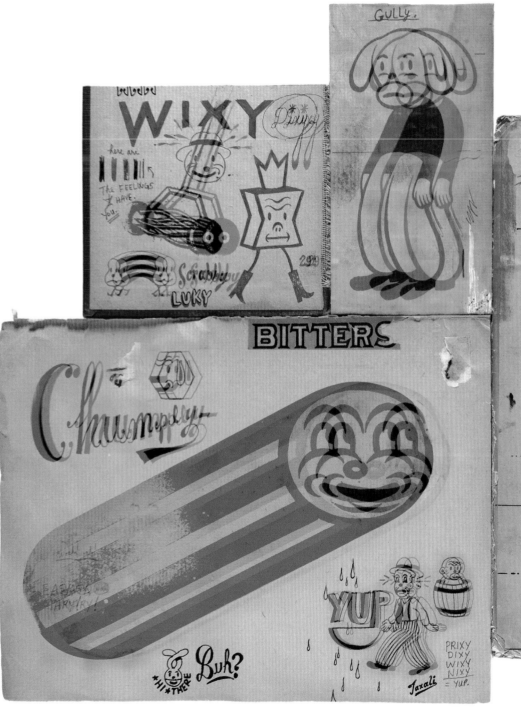
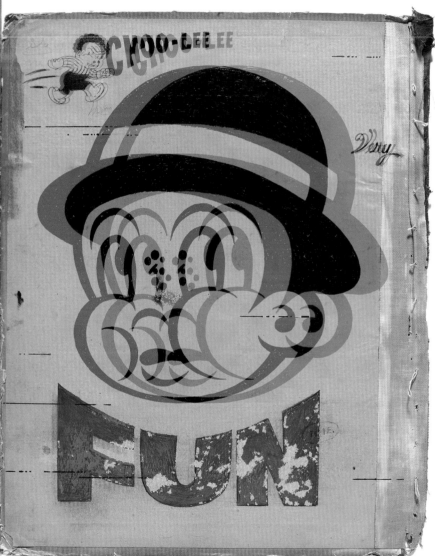

**Kevin Bourgeois**
*The Merchants of Cool, 2009*

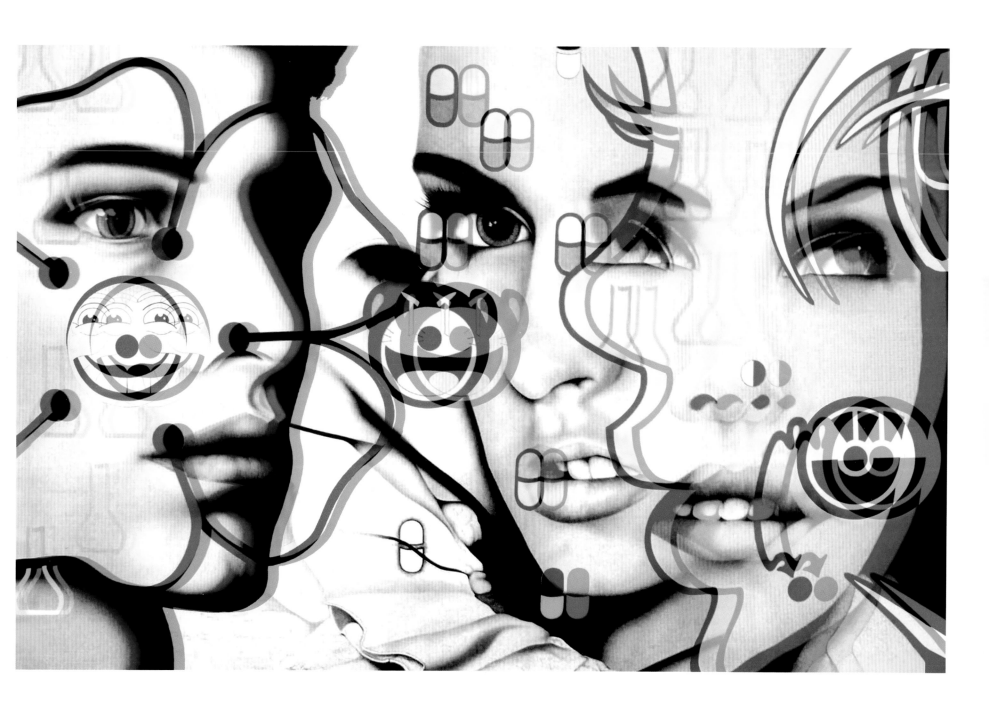

**Gomez Bueno**
*Juanito El Sucio,* 2009

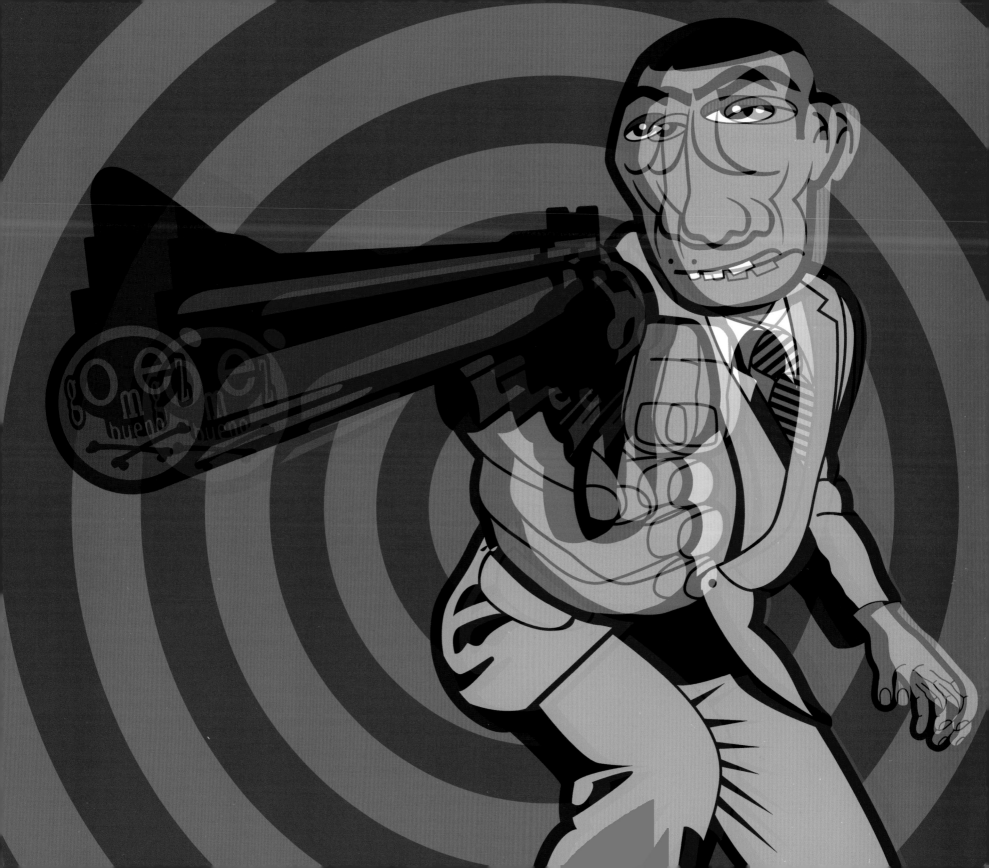

*previous spread:* **Mint and Serf**
*Untitled,* 2010

**Junko Mizuno**
*Volcano Party,* 2009

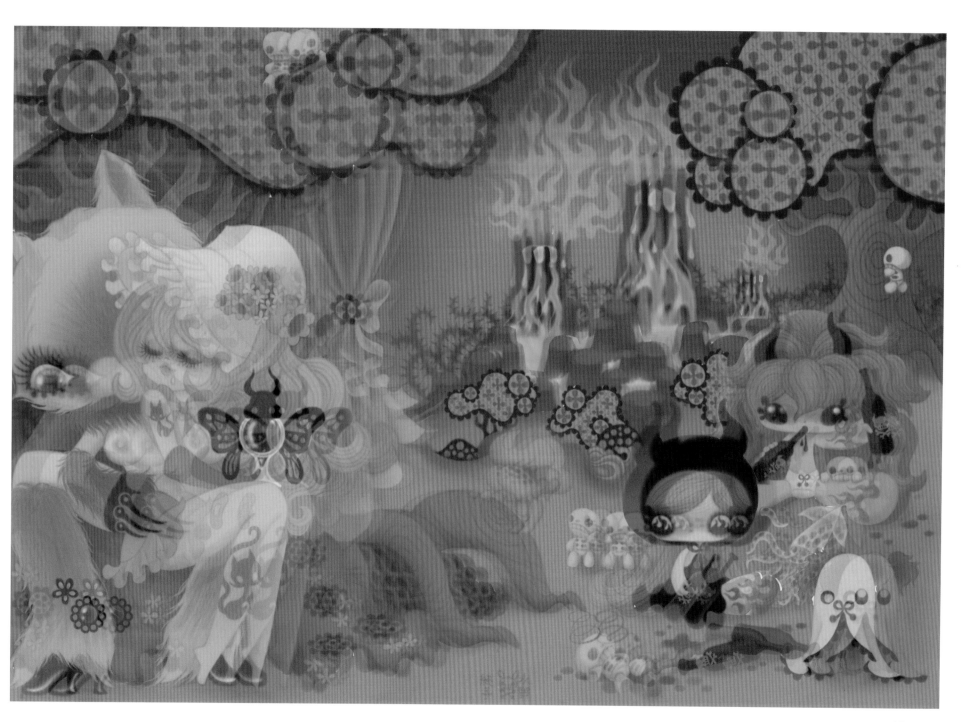

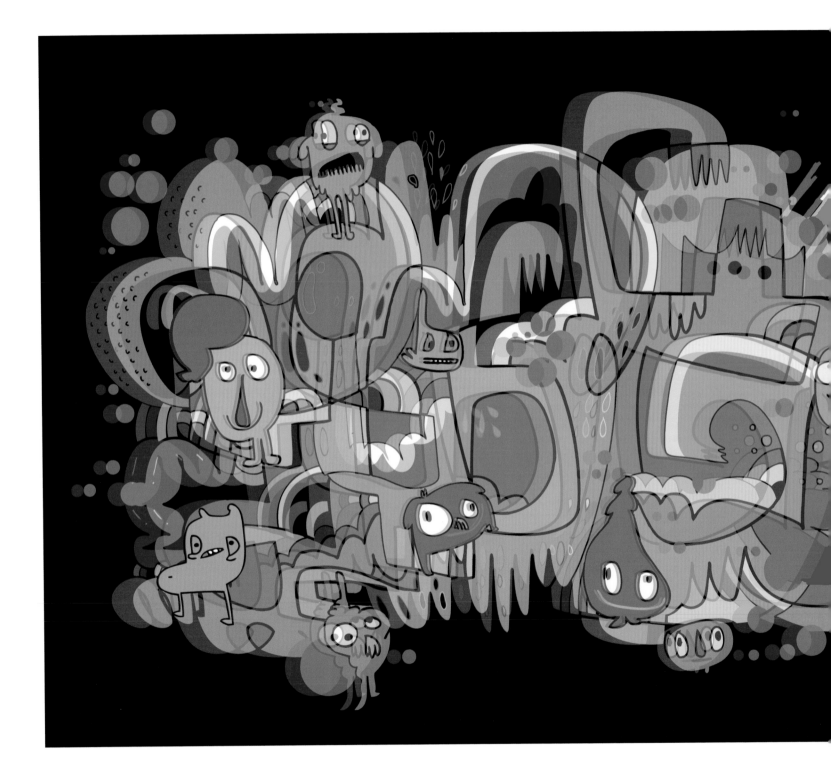

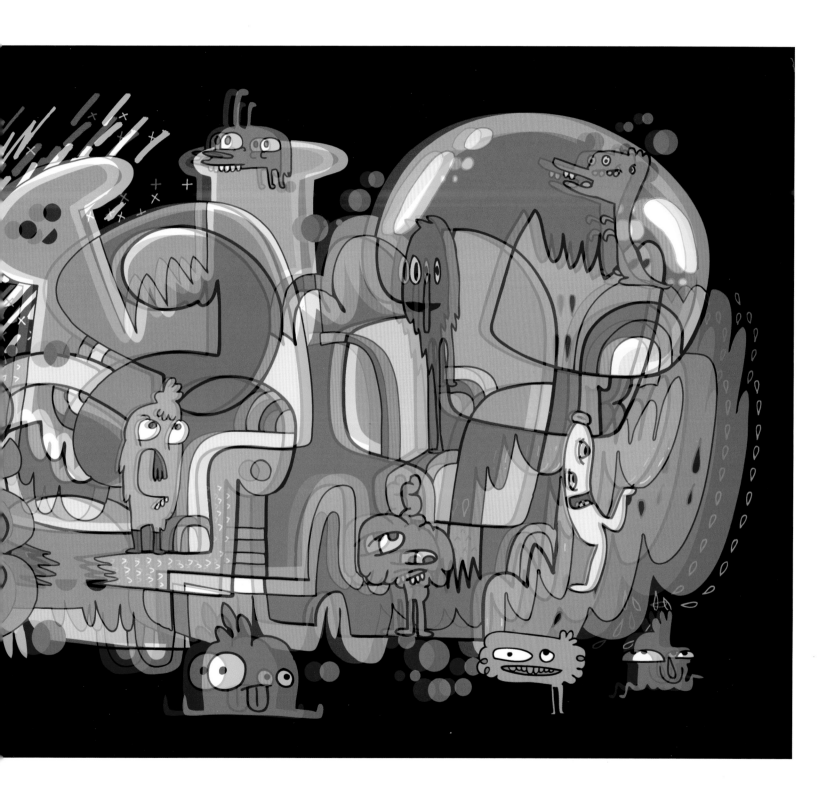

51

*previous spread:* **Jon Burgerman**
*Untitled, 2010*

**Books**
*Tragic Nights, 2009*

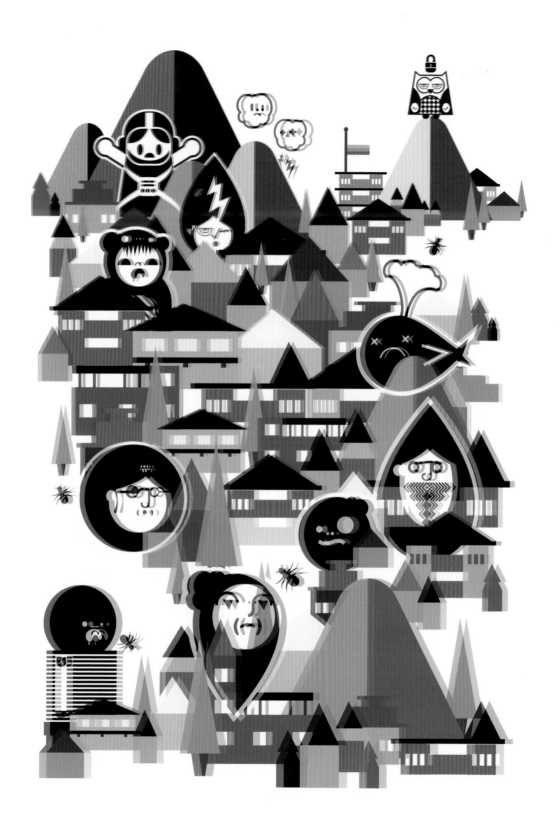

**Calma**
*Death is a Holiday, 2008*

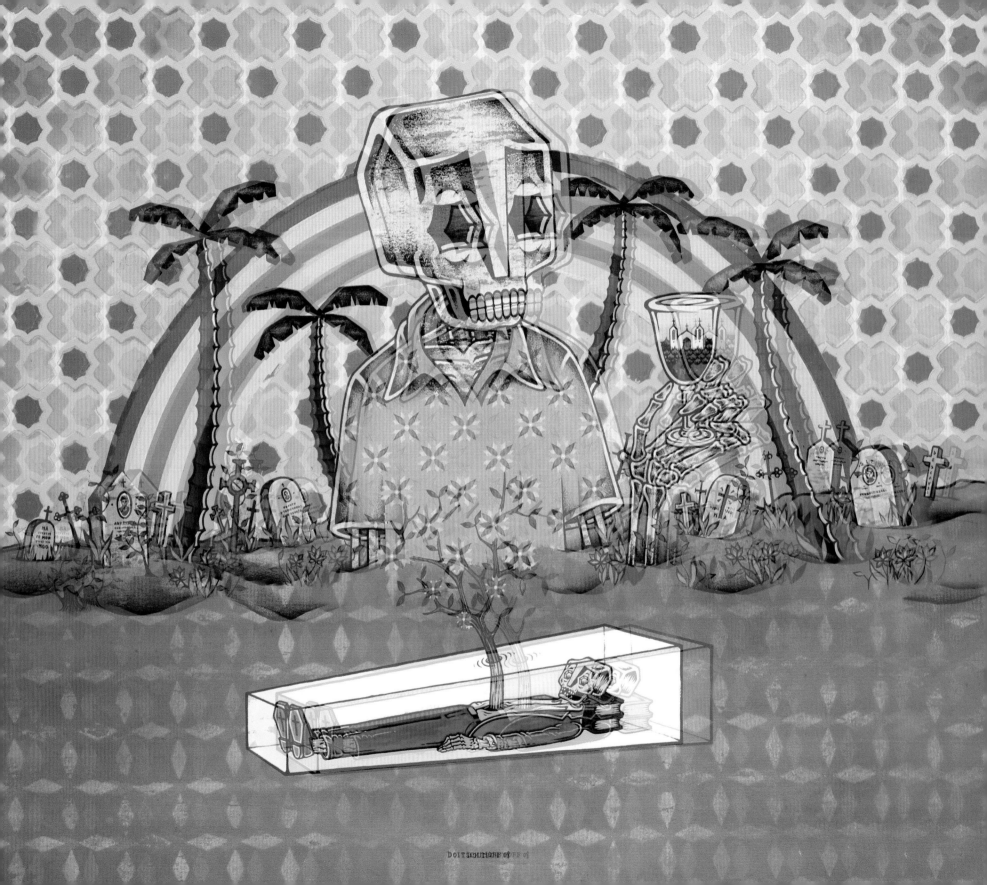

Mark Dean Veca

*As Cold As They Come, Part II, 2009*

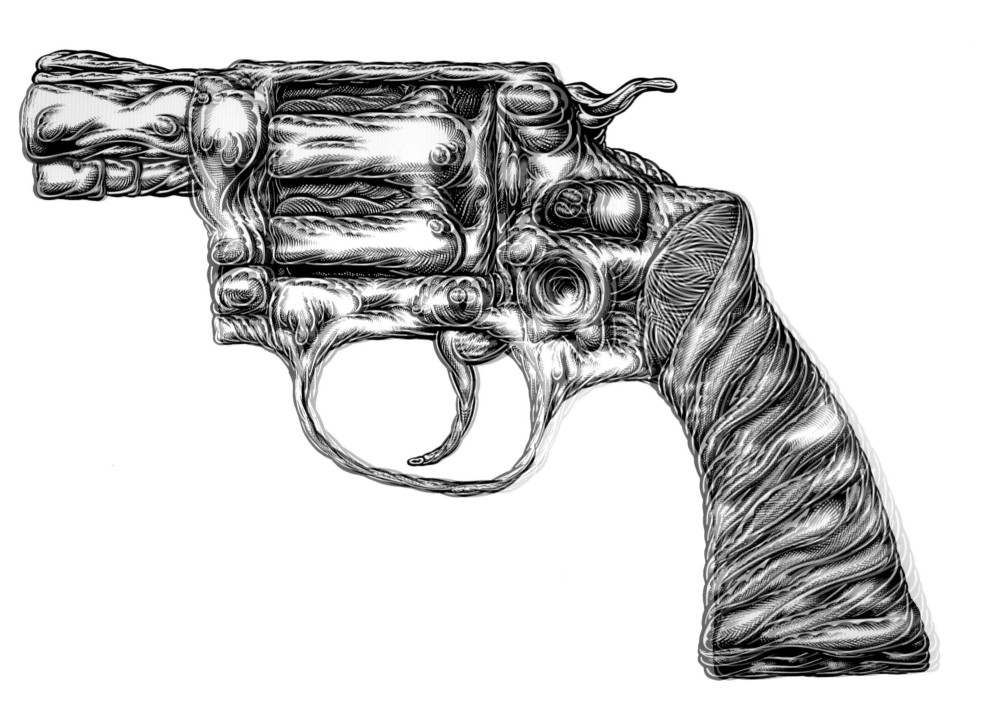

Matt Campbell

*Sad Seal,* 2008

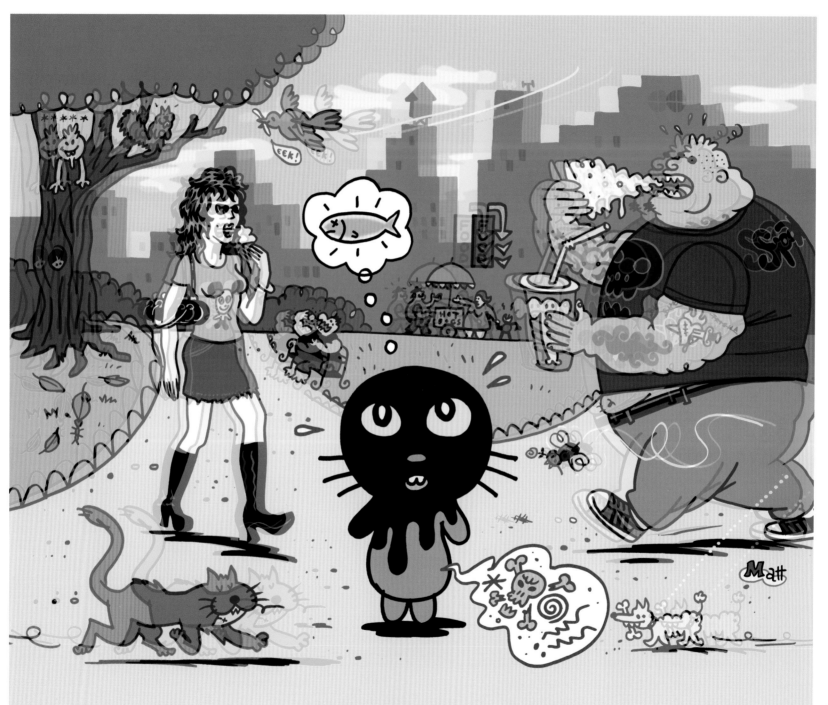

Stanley Chow

*Welcome to Manchester*, 2010

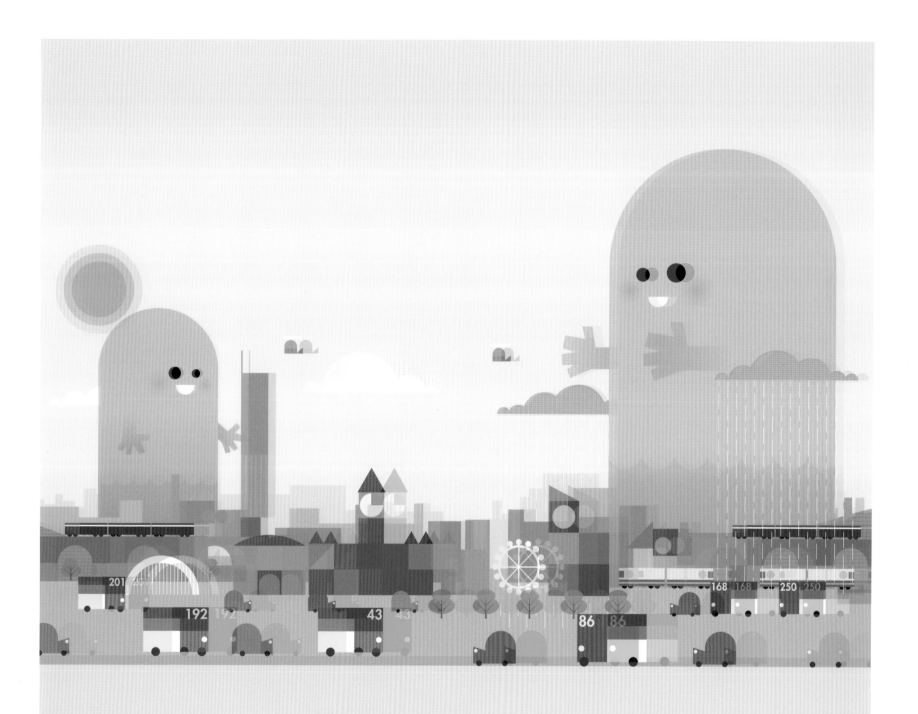

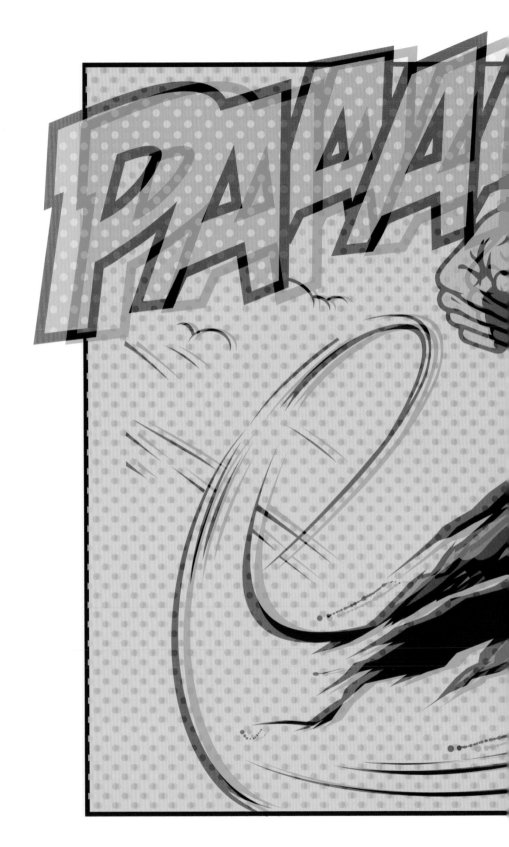

**D*Face**

*Dead Superman, 2010*

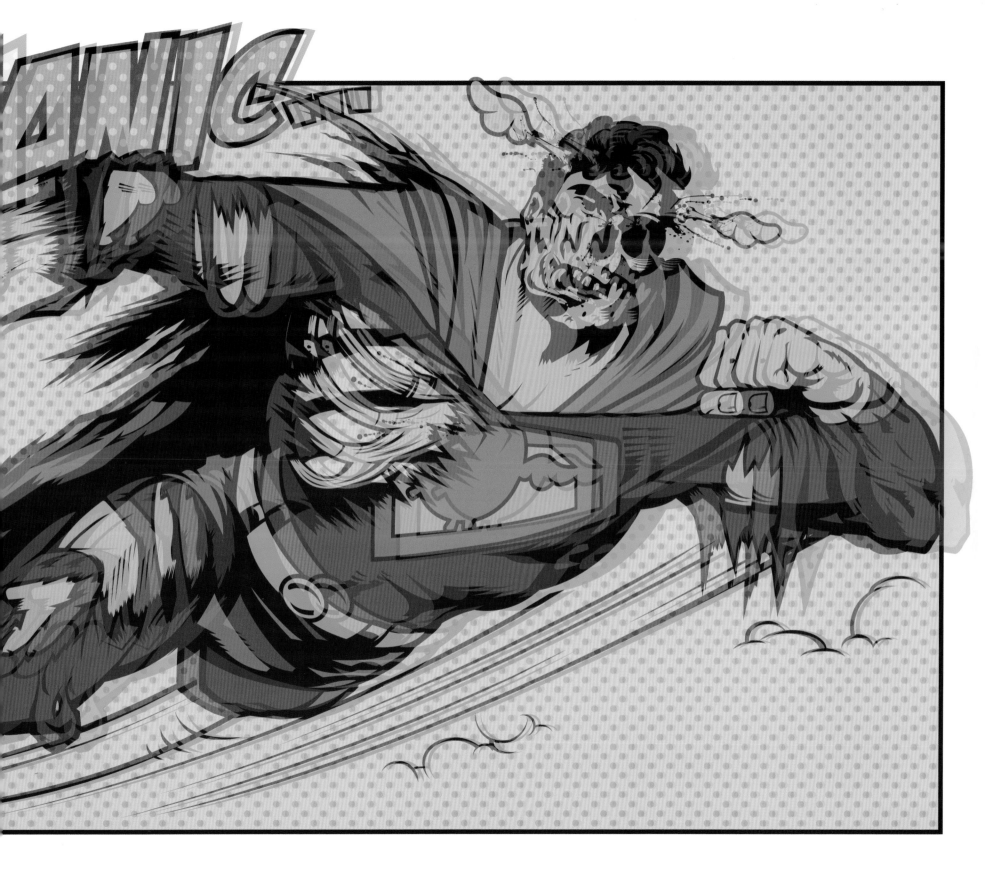

Craola
*The Pearl Thief,* 2010

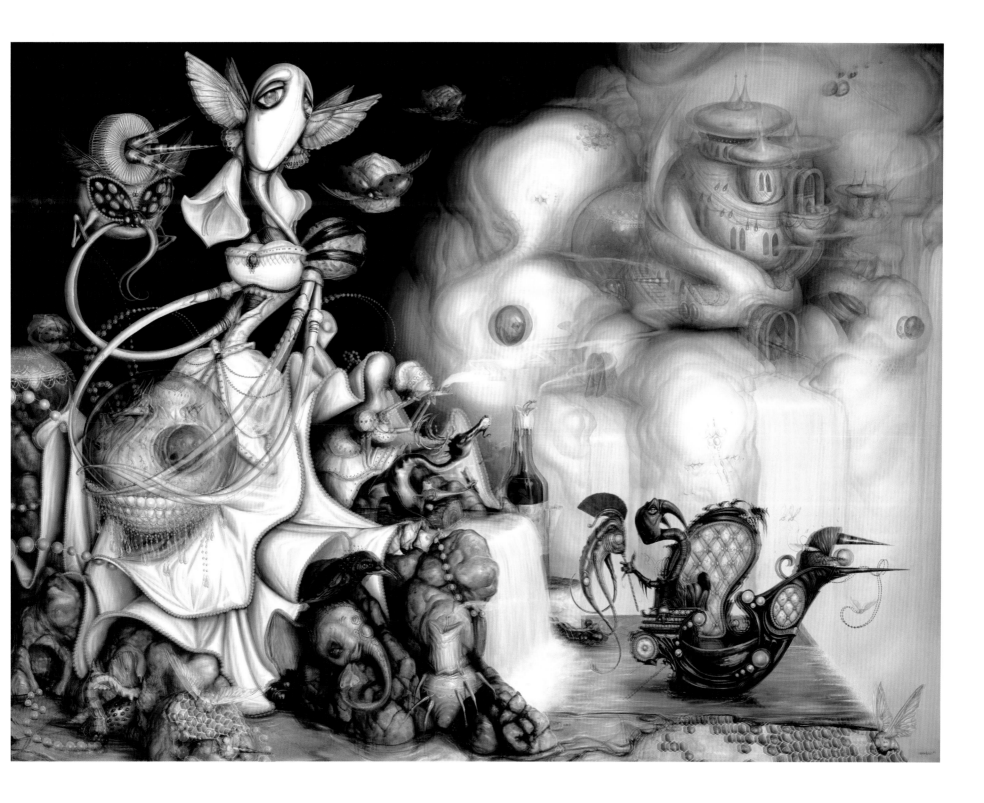

Dabs and Myla
*Super Fantastic,* 2010

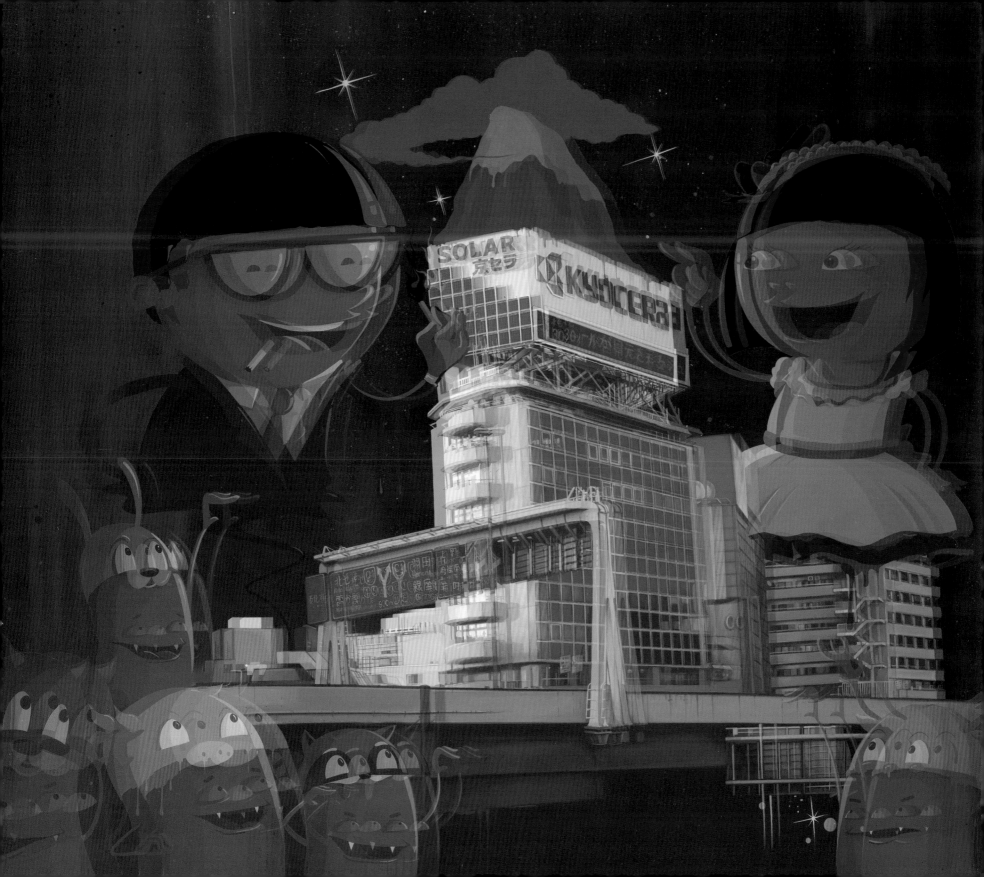

Tristan Eaton
*Wild Beauty, 2009*

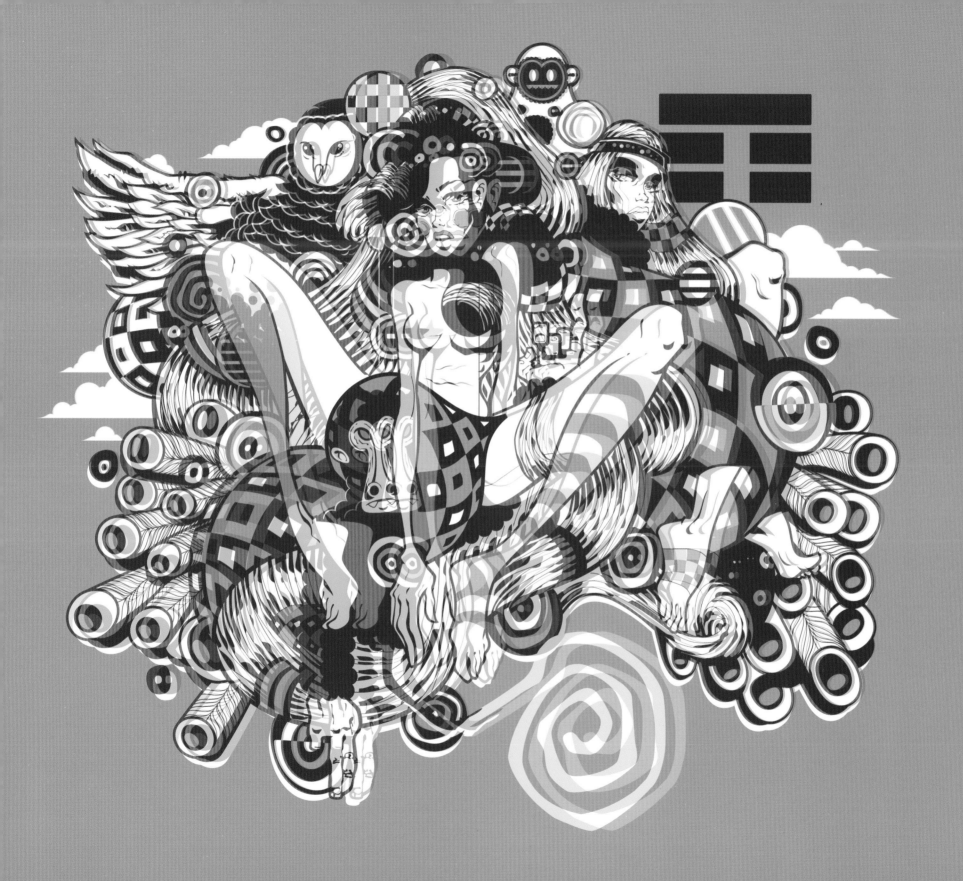

Dave Cooper

*Arm of Hosts,* 2008

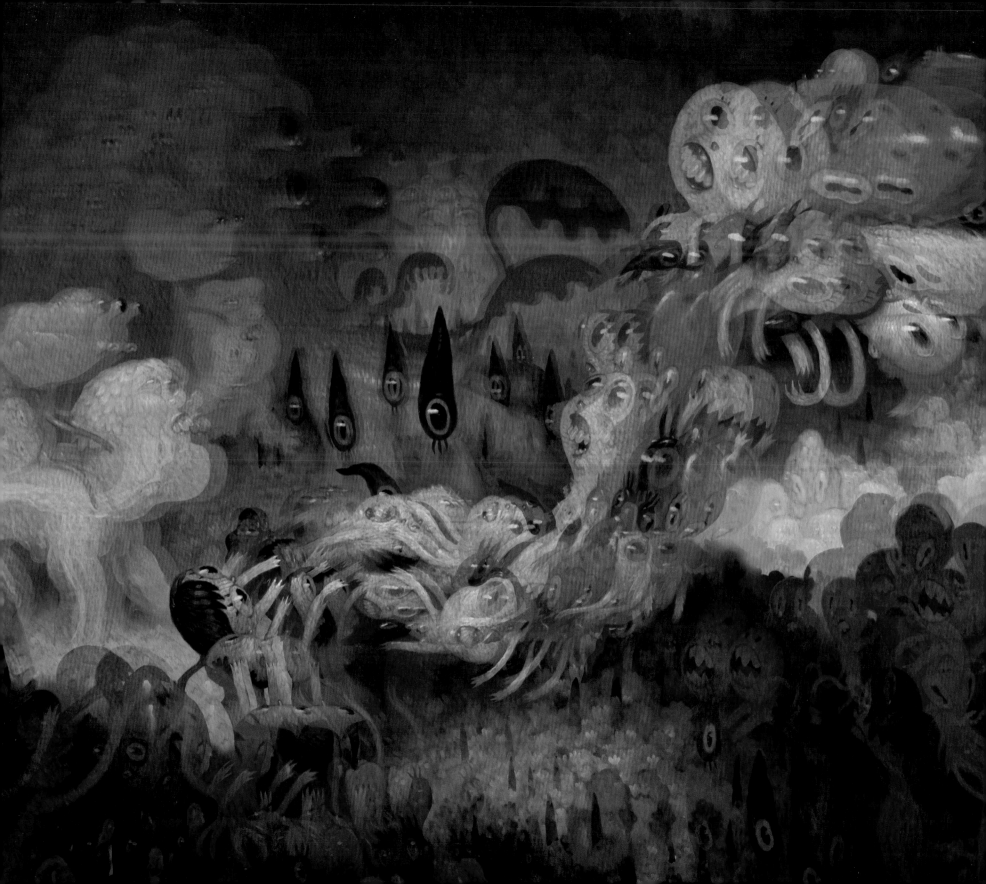

Esao Andrews
*Quilted Sails,* 2010

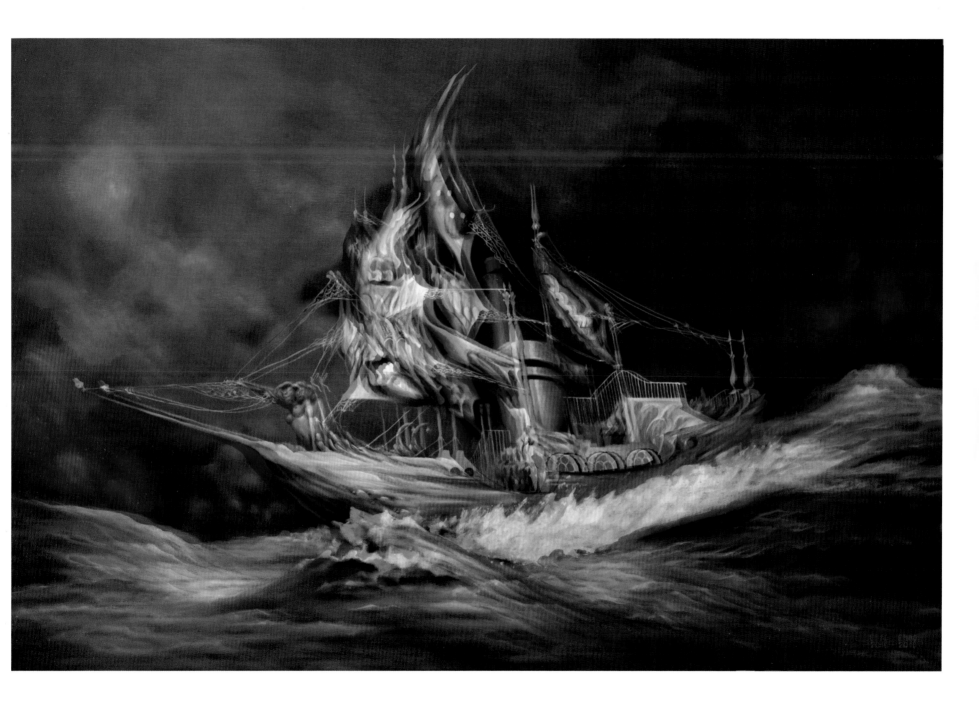

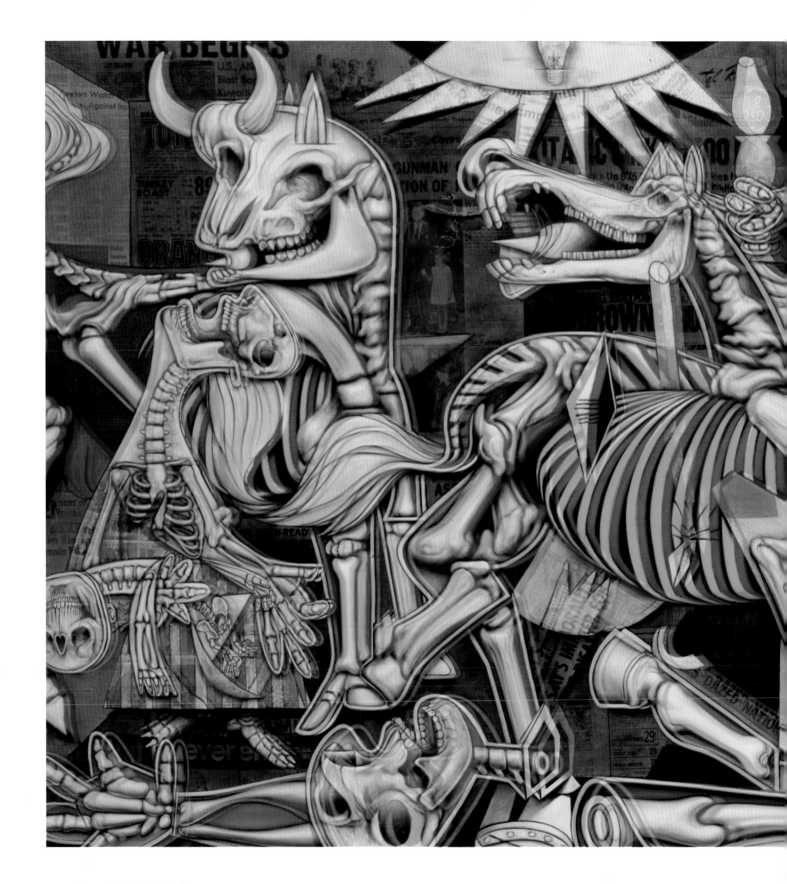

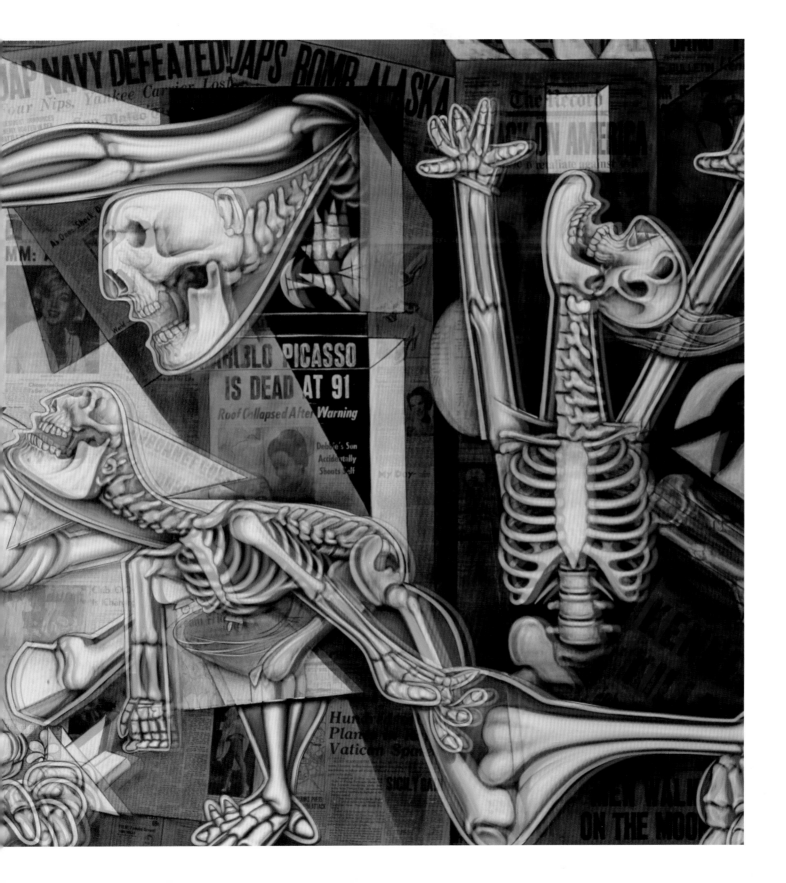

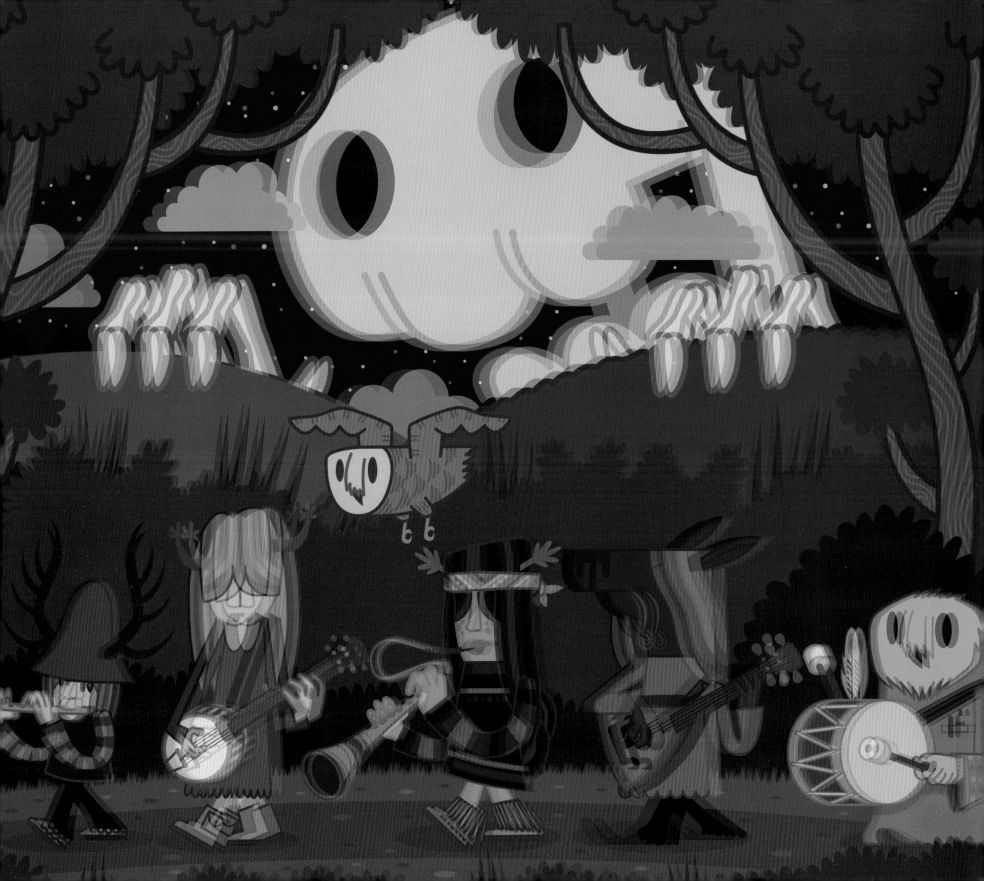

**Logan Hicks**
*Steel Reflecting Pool,* 2010

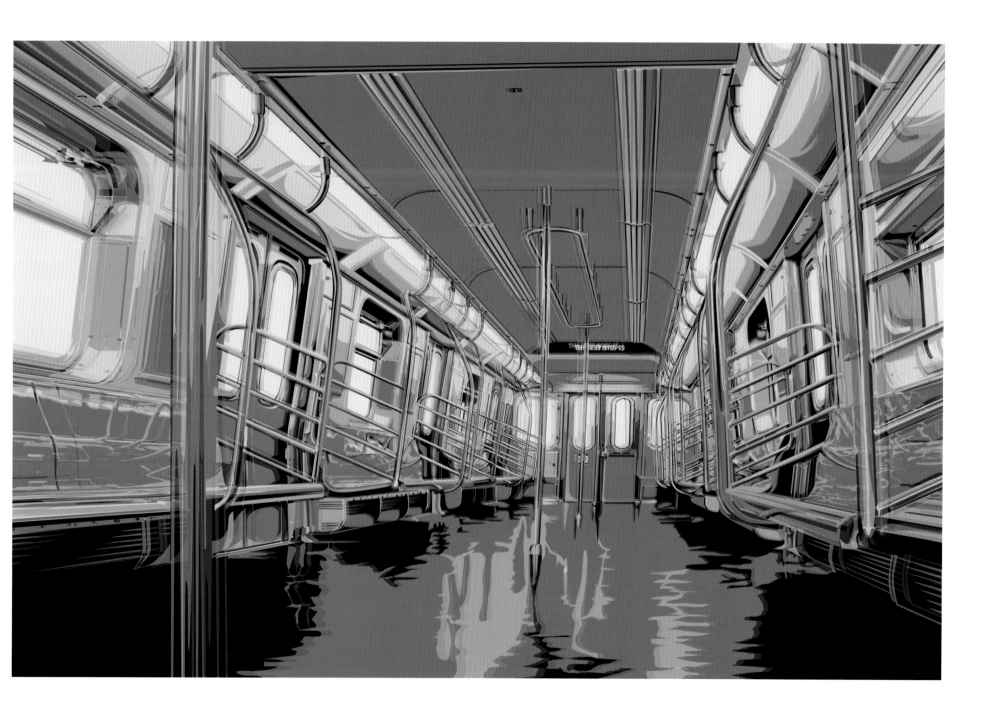

DEMO

*Untitled,* 2009

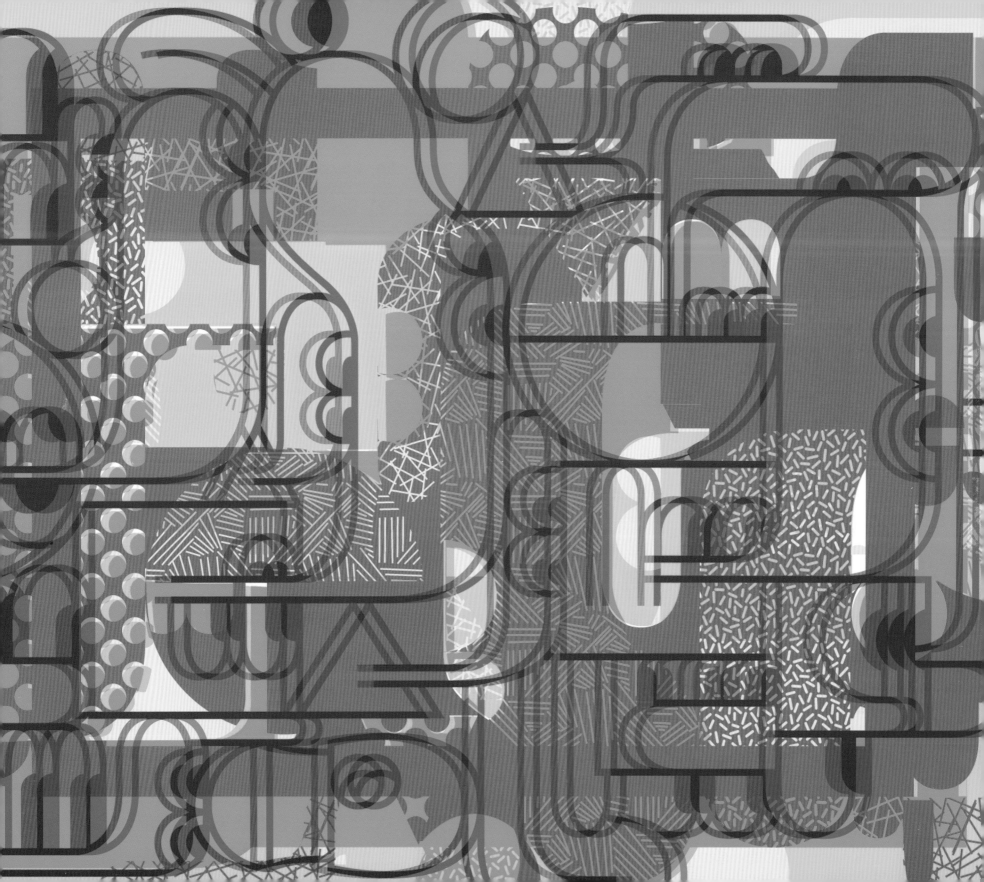

Dr. Revolt
*Untitled*, 2010

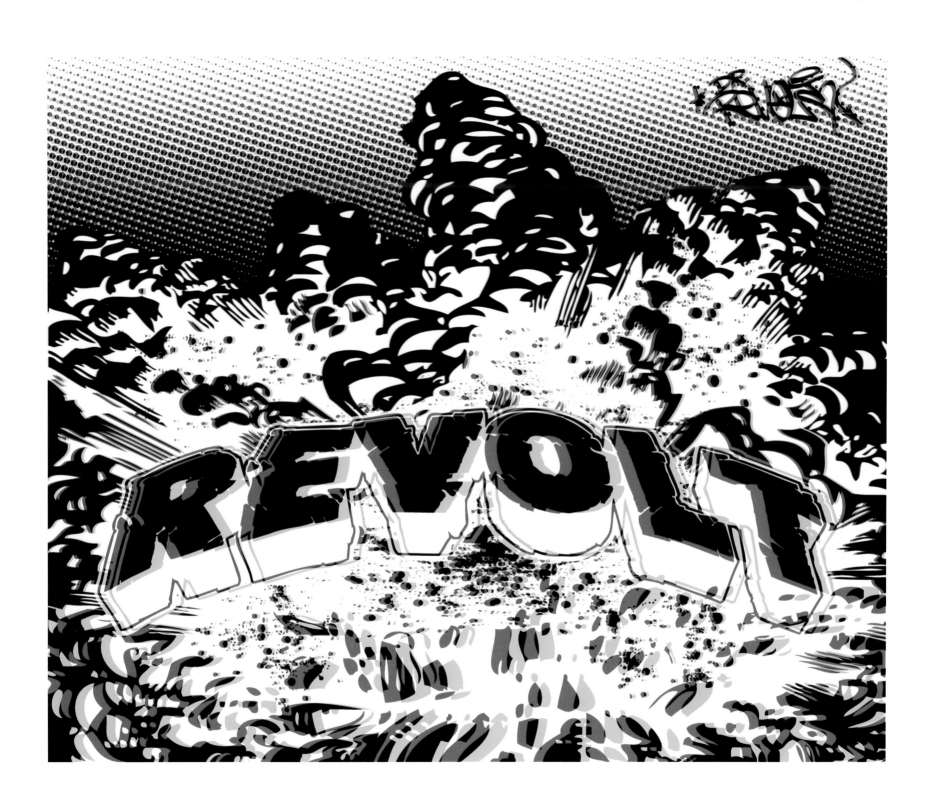

**Matt Eaton**

*Loaf,* 2010

Shepard Fairey
*Two Sides of Capitalism: Bad, 2007*

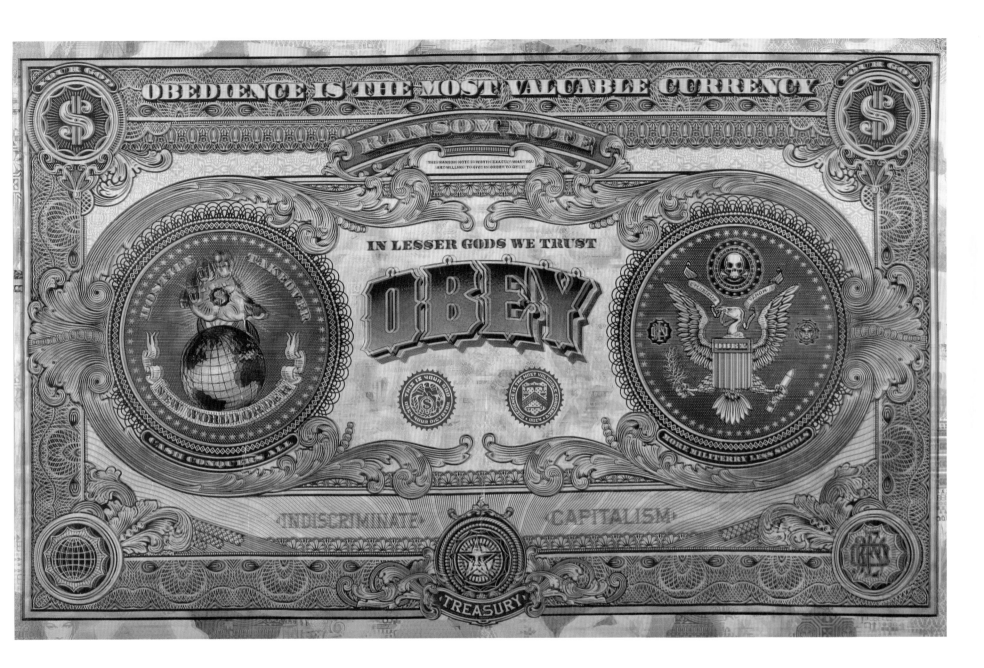

Shepard Fairey

*Two Sides of Capitalism: Good, 2007*

**Jerry Abstract**
*Untitled*, 2008

**TrustoCorp**
*American Beef, 2010*

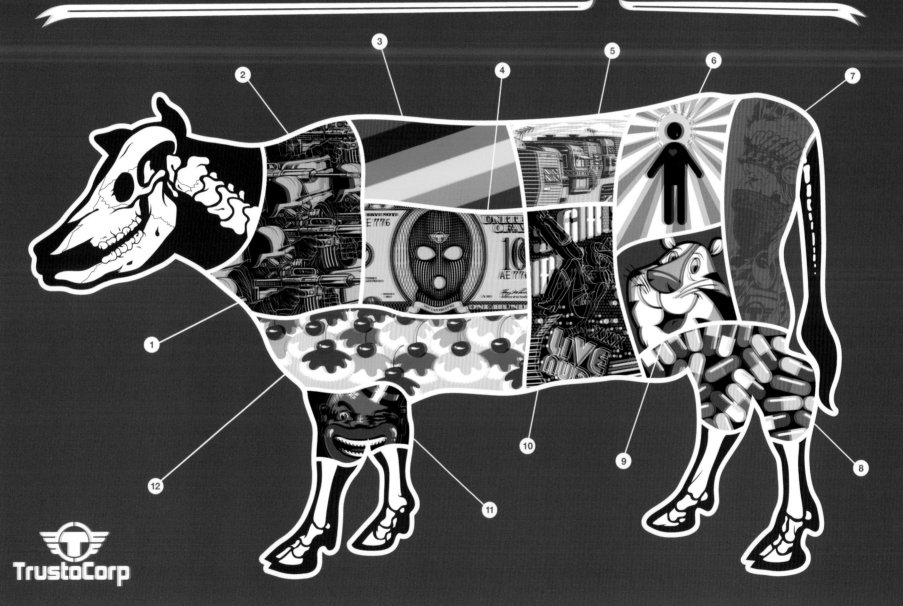

**Rich Jacobs**
*Alone, Even in a Crowd, 2010*

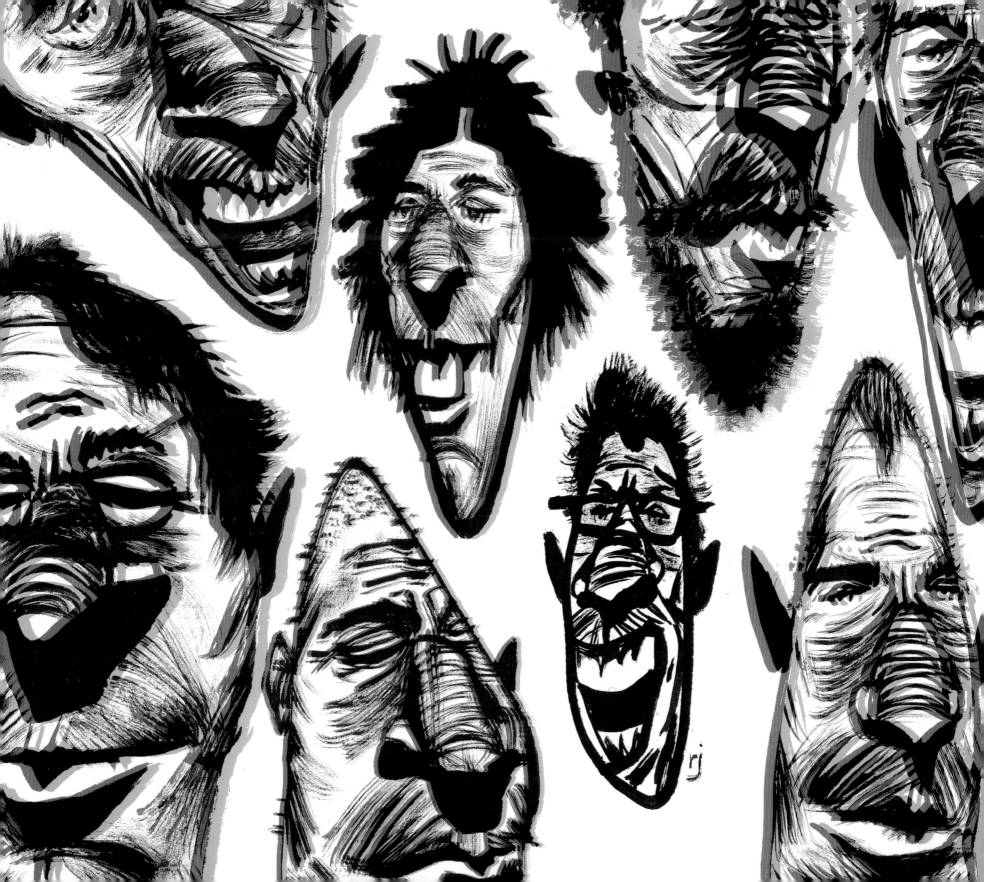

**Mark James**

*Cardboy Orange, 2010*

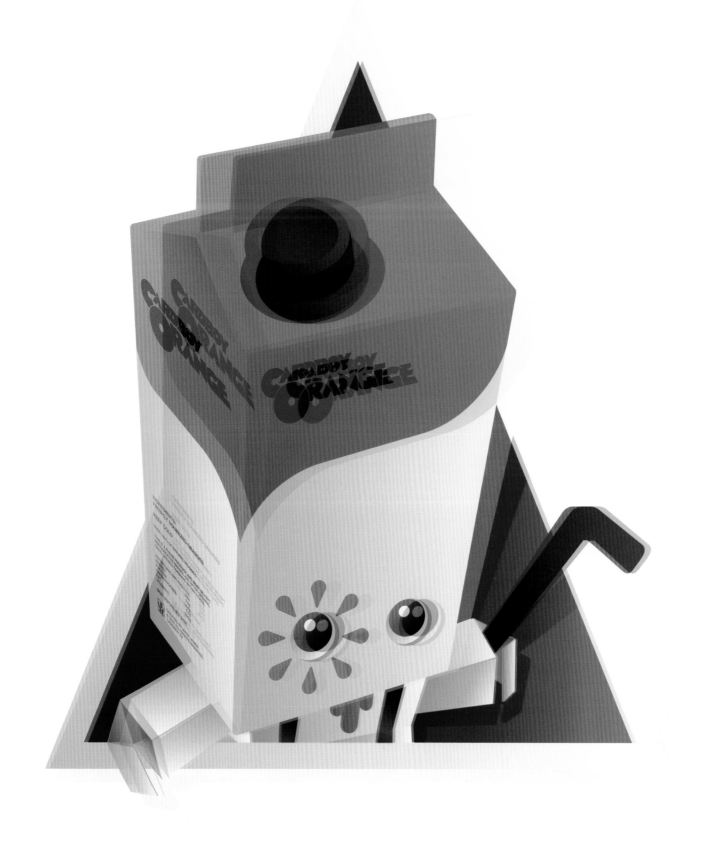

**James Jean**

*Shattered,* 2008

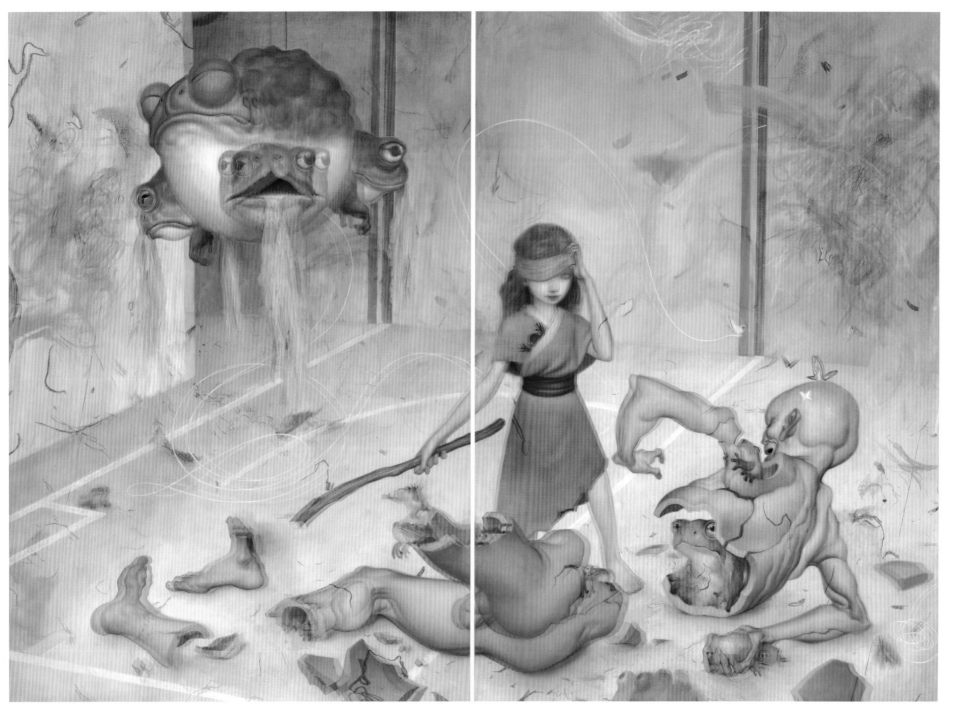

Adrian Johnson
*Untitled*, 2010

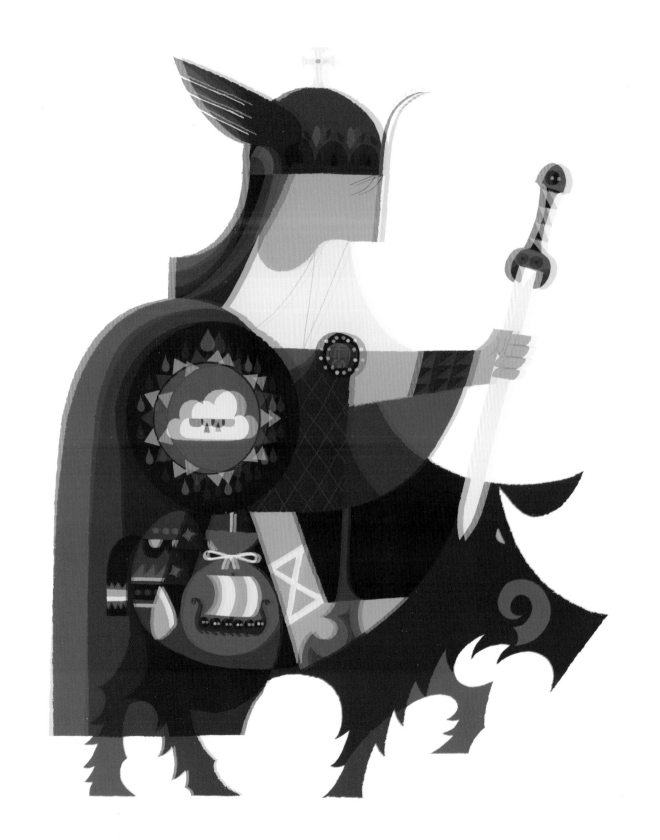

Dave Kinsey
*Inhumanate*, 2008

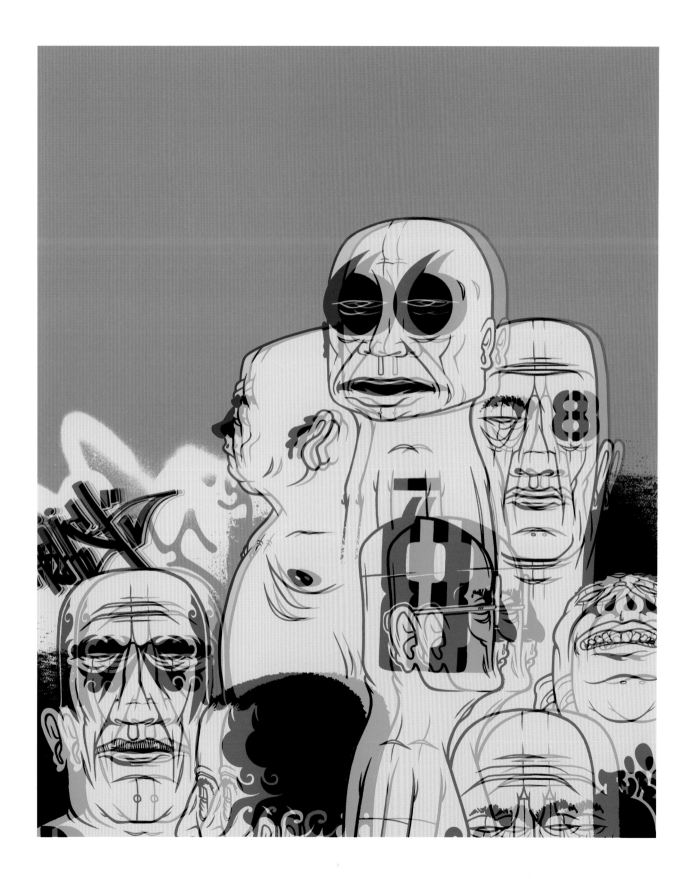

Laura Barnhard
*Social Restraint*, 2006

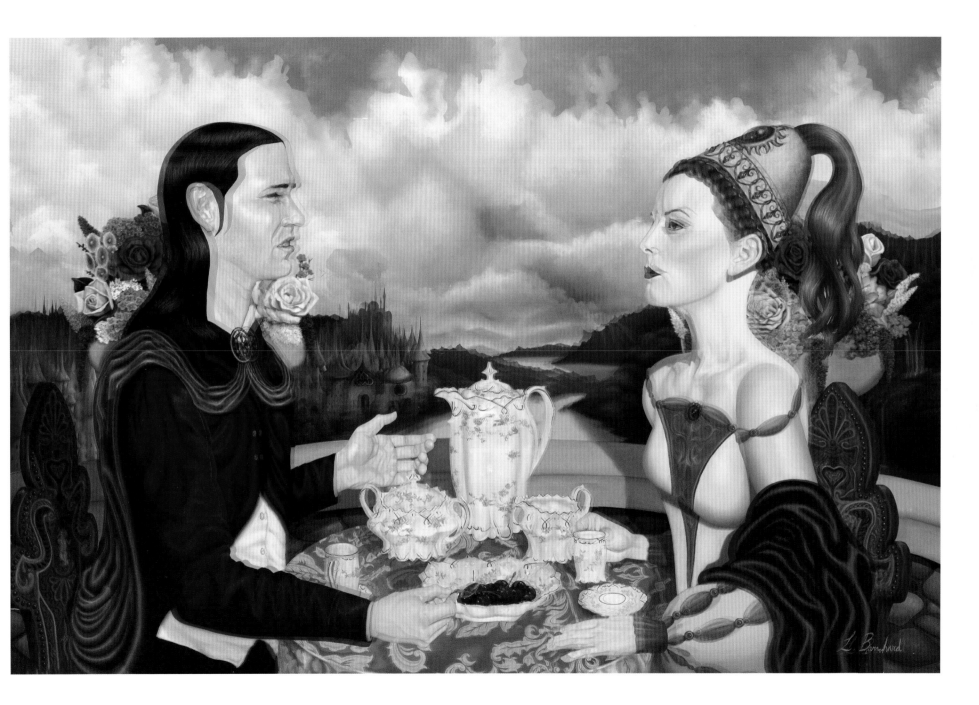

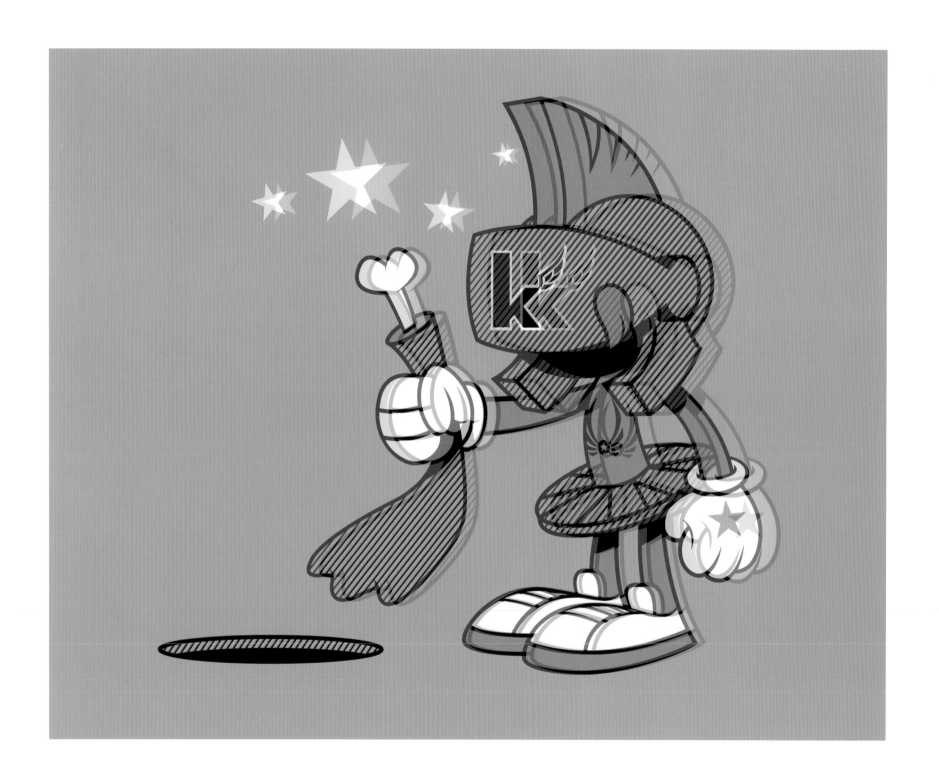

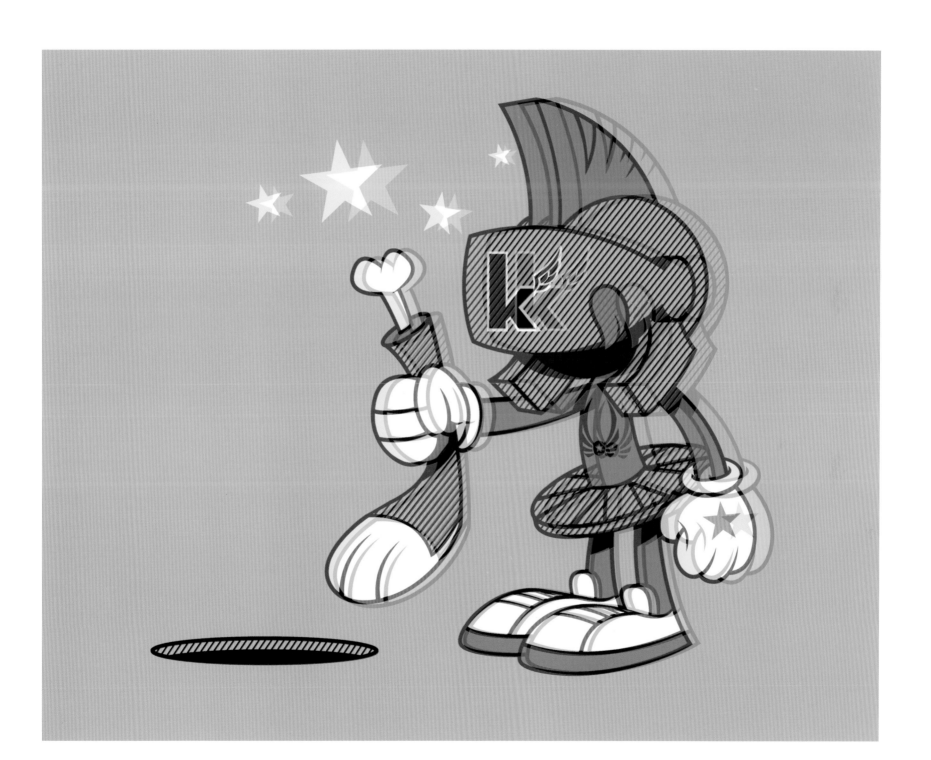

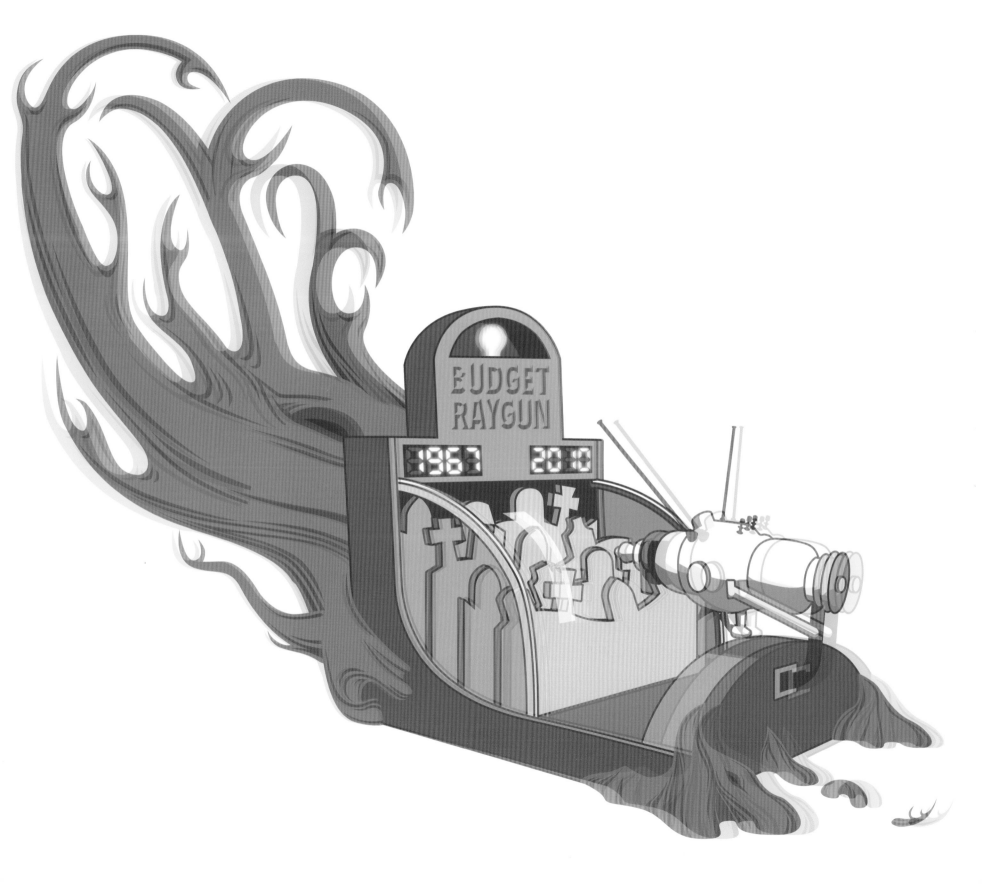

**Kid Acne**
*Dance Night,* 2010

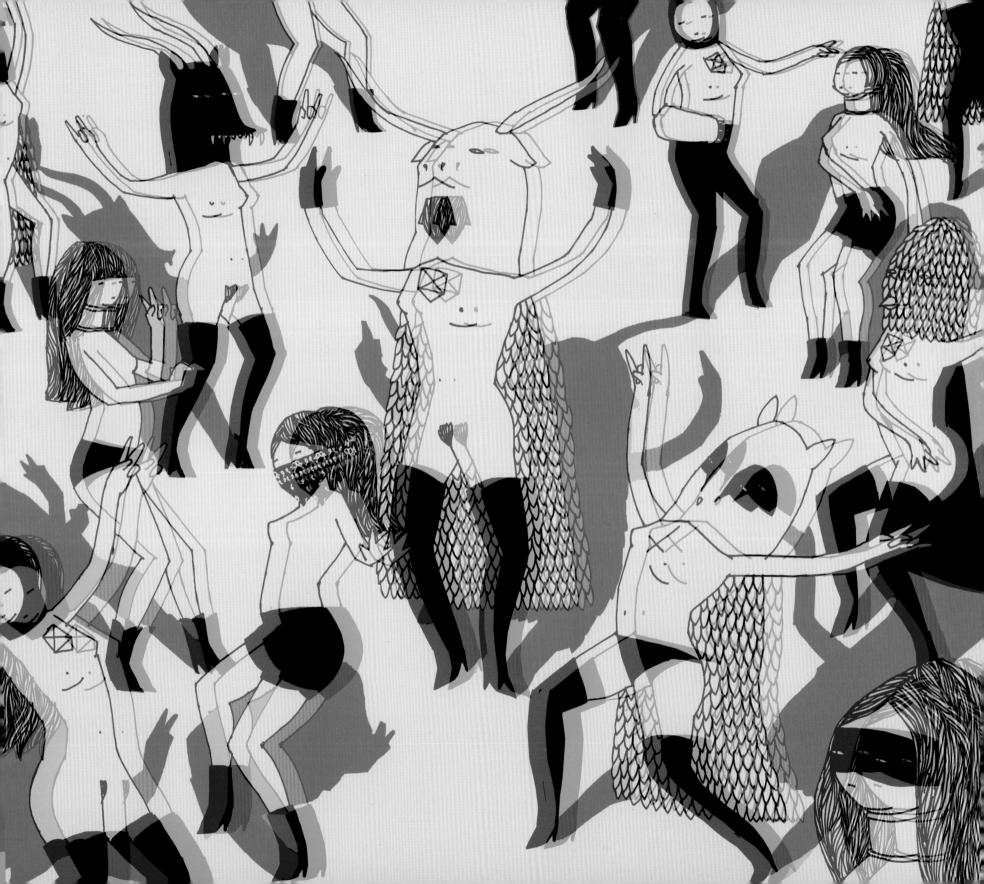

Jeremy Madl

*Modern Hero, 2008*

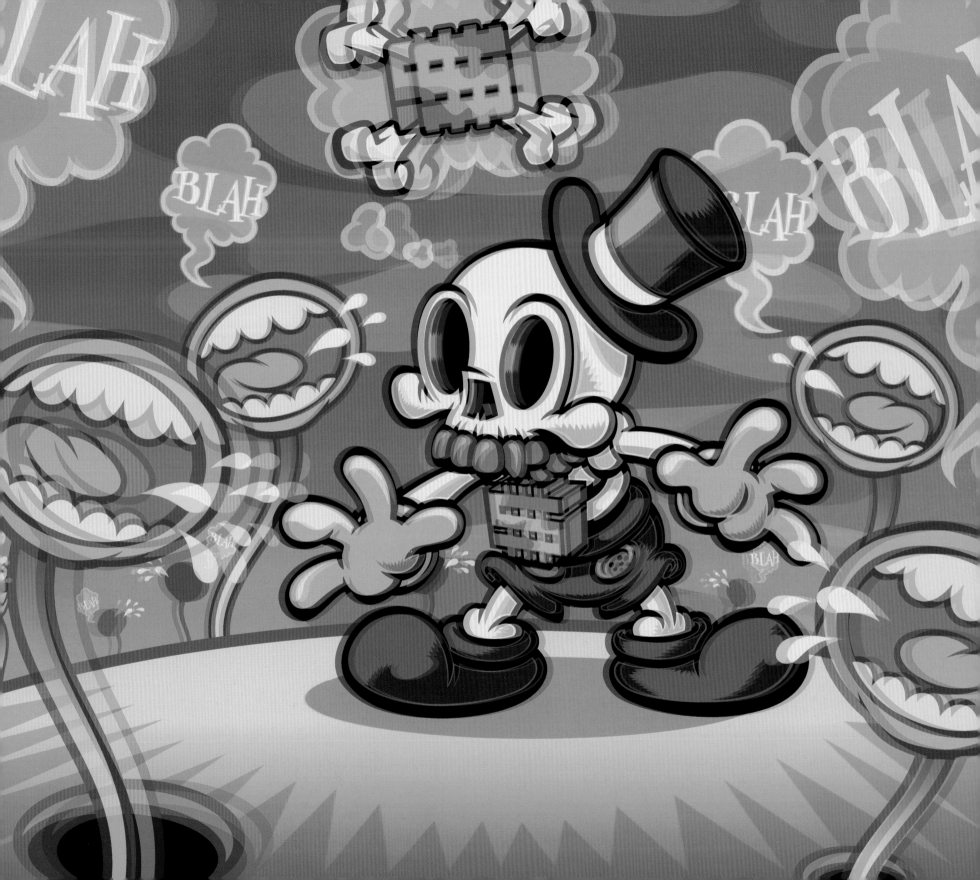

previous spread: **Kenzo Minami**
*Chambre Avec Vue, 2010*

**Travis Millard**
*Hug It Out, 2009*

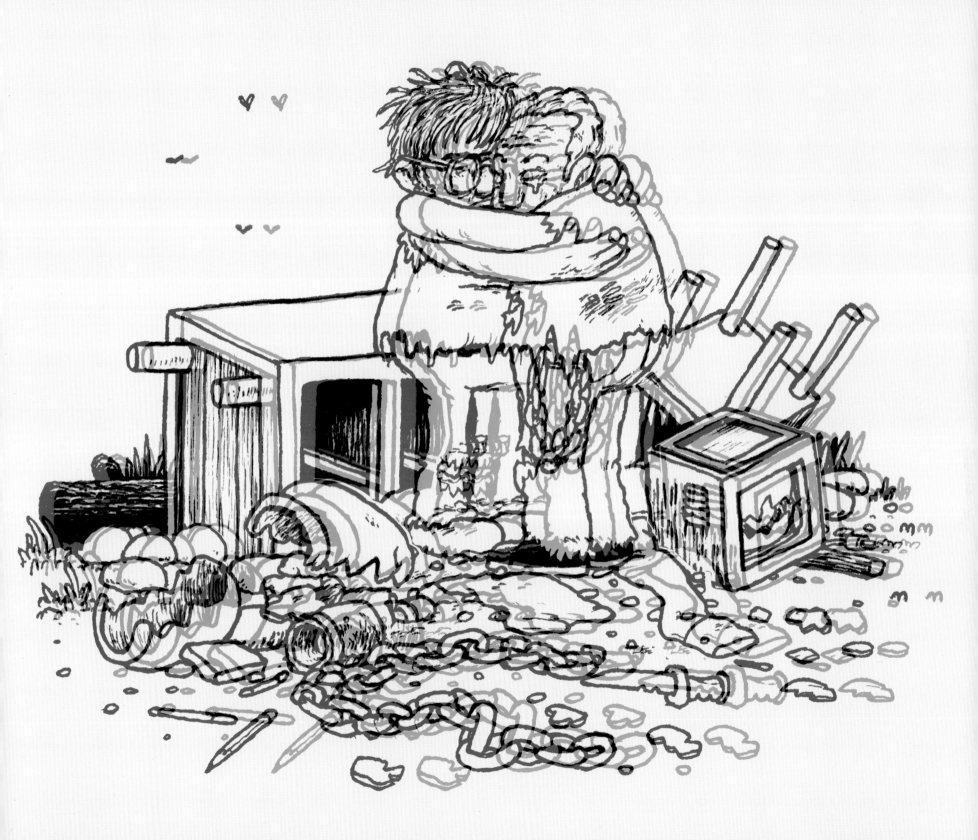

**Mark Bode**
*Cobalt 60, 2010*

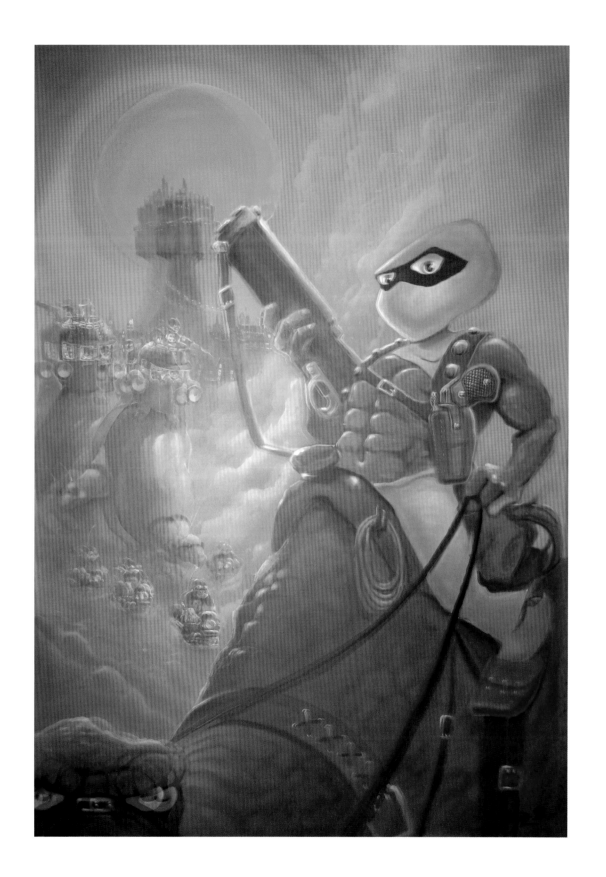

Jim Mahfood
*Disco Destroyer,* 2010

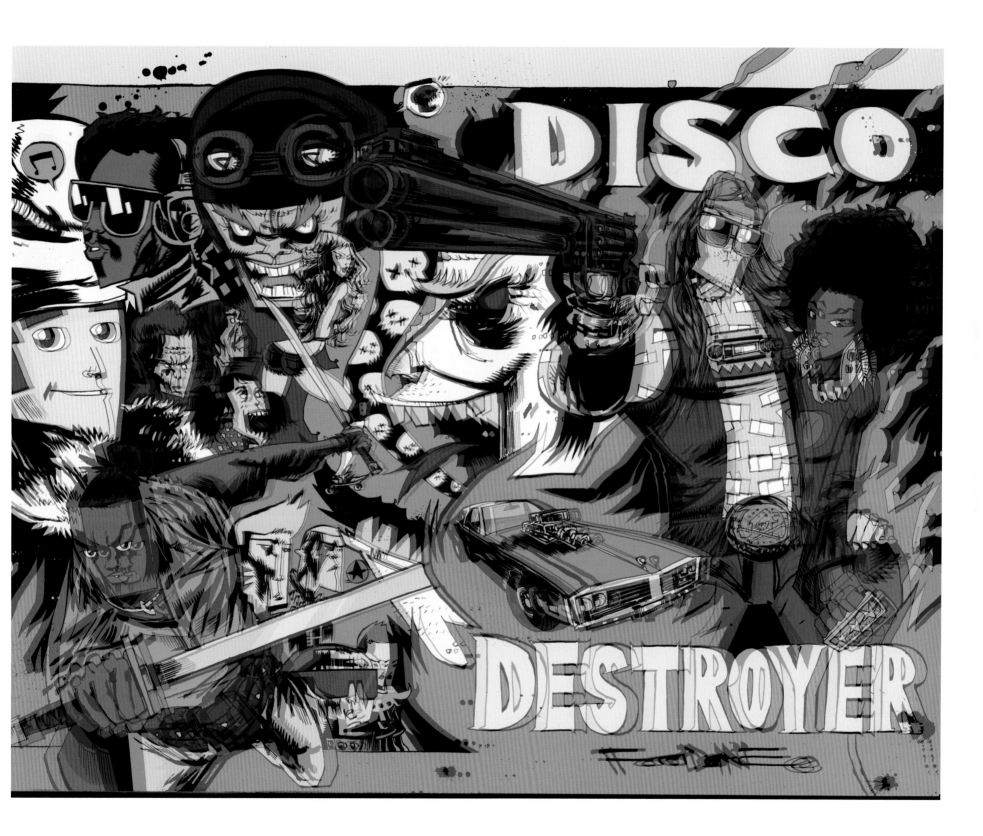

Mark Ryden
*The Magic Circus*, 2001

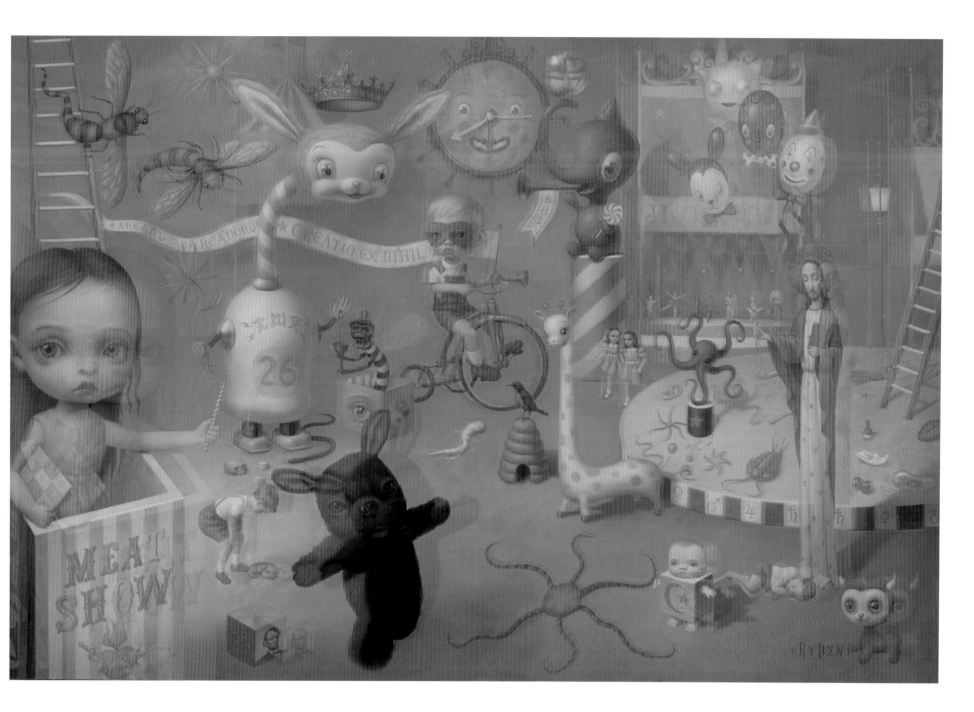

*previous spread:* **Bill McMullen**

*Never Breathe a Word About Your Loss,* 2010

**Chris Mars**

*Healing by Way of the Ace of Blurred Matter,* 2009

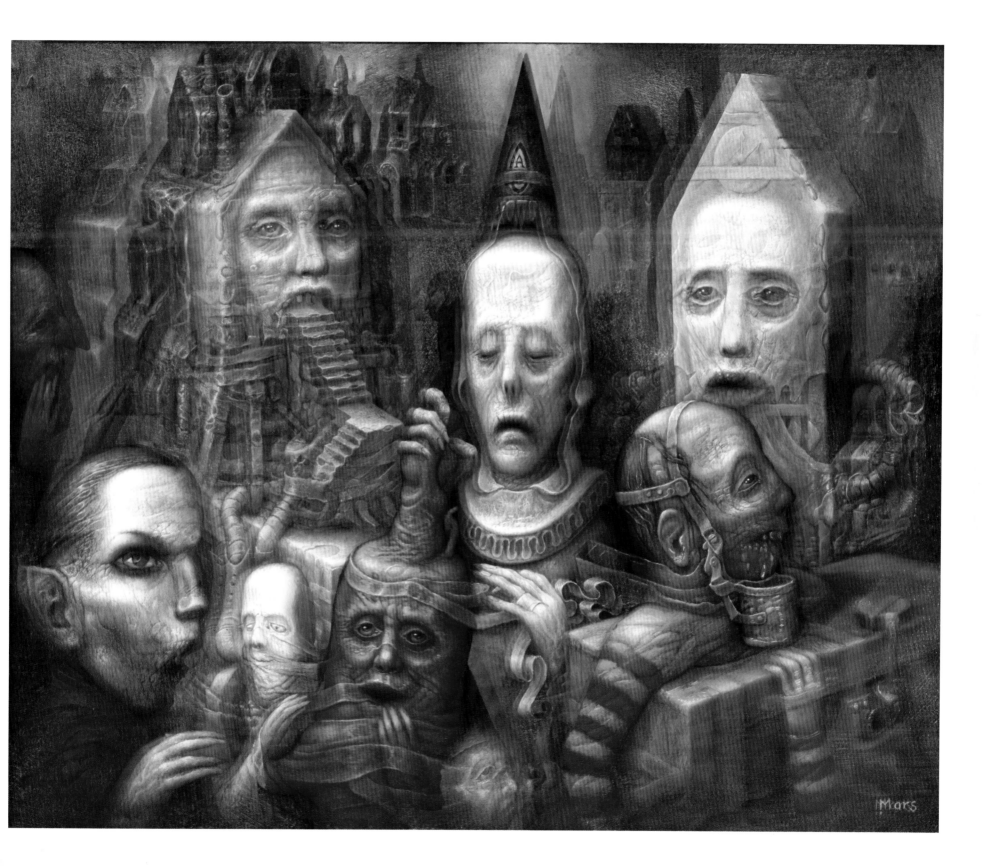

**Miss Van**

*Mascaras 4, 2010*

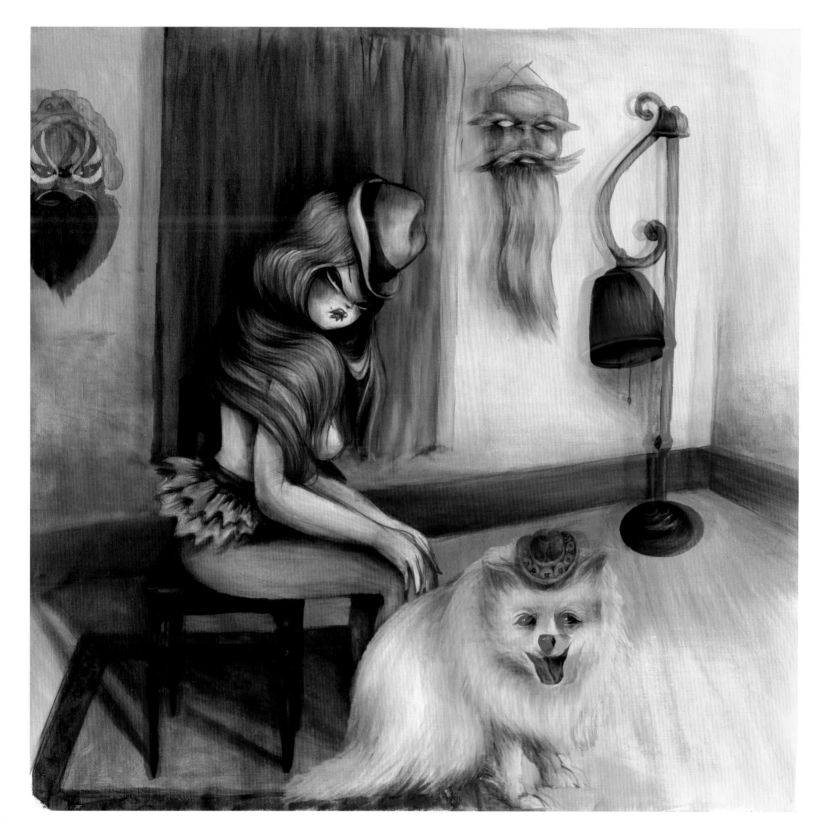

**Maya Hayuk**
*A Path for the Light, 2009*

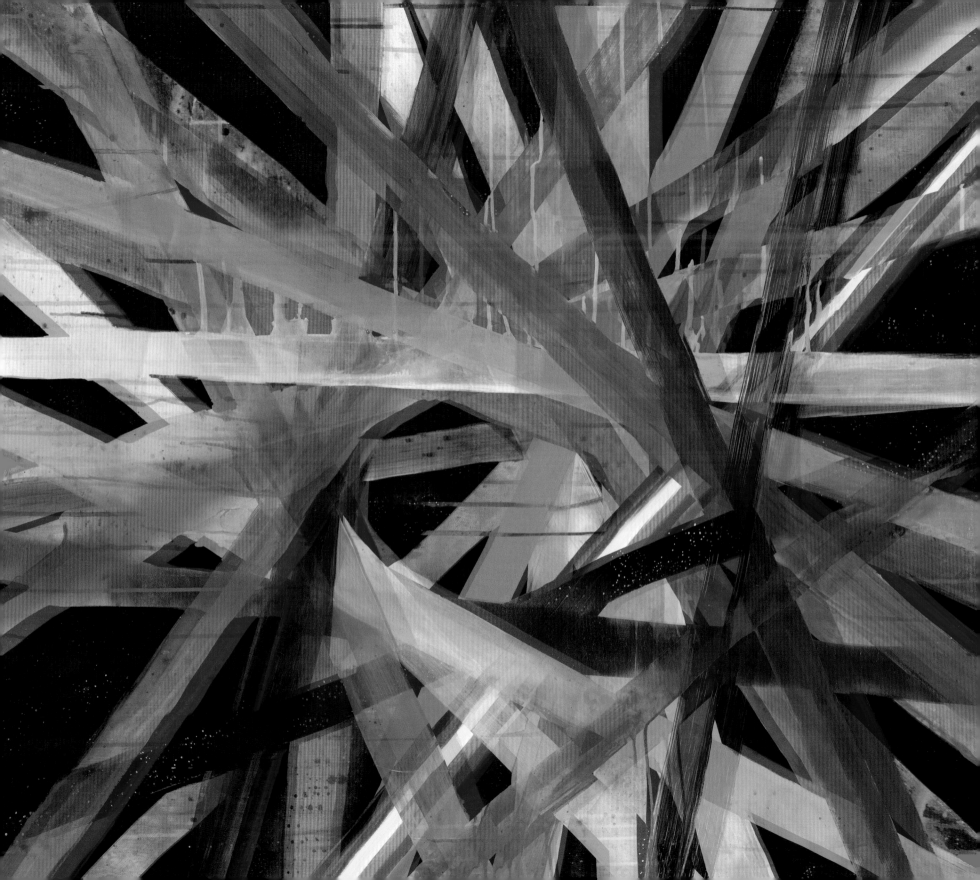

**Morning Breath**

*Steaks are High, 2010*

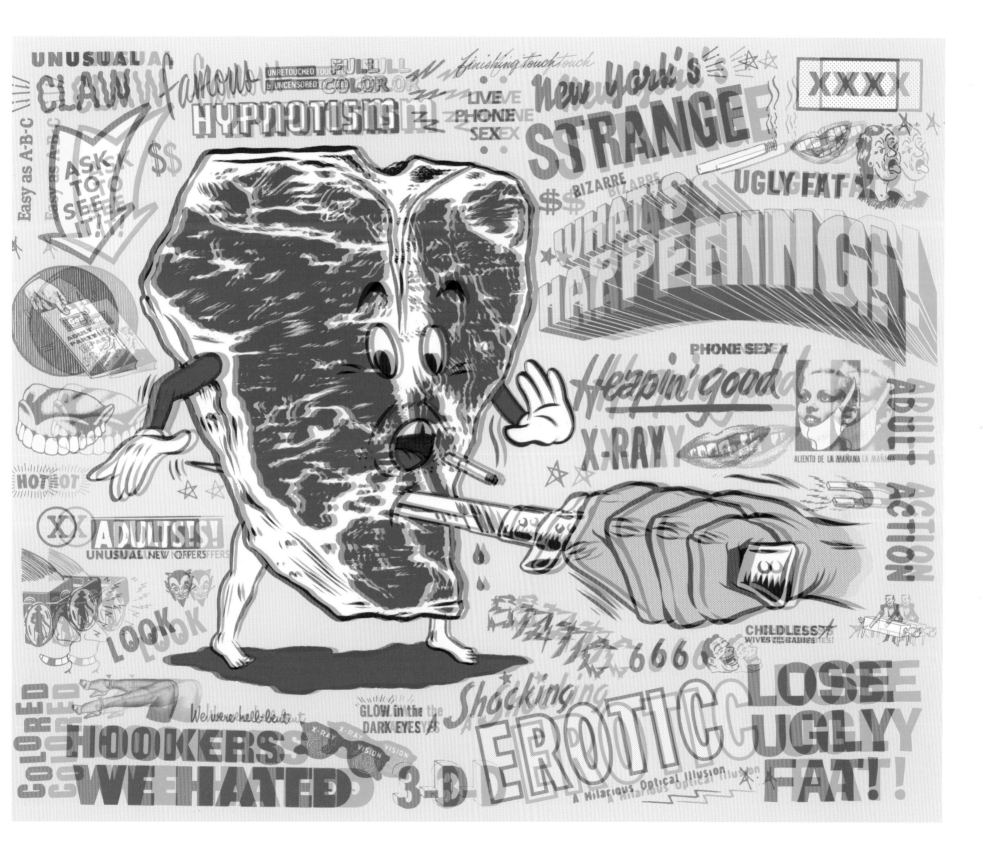

Jeff Soto
*Untitled*, 2010

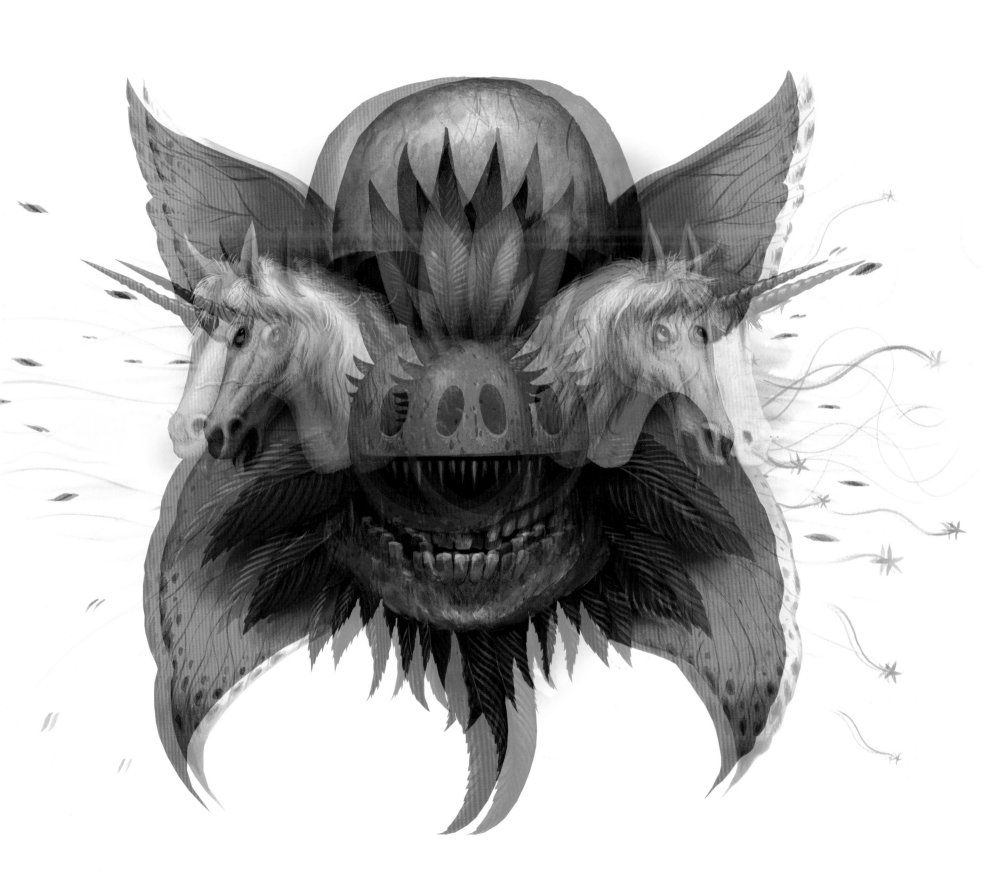

Michael De Feo
*Untitled, 2008*

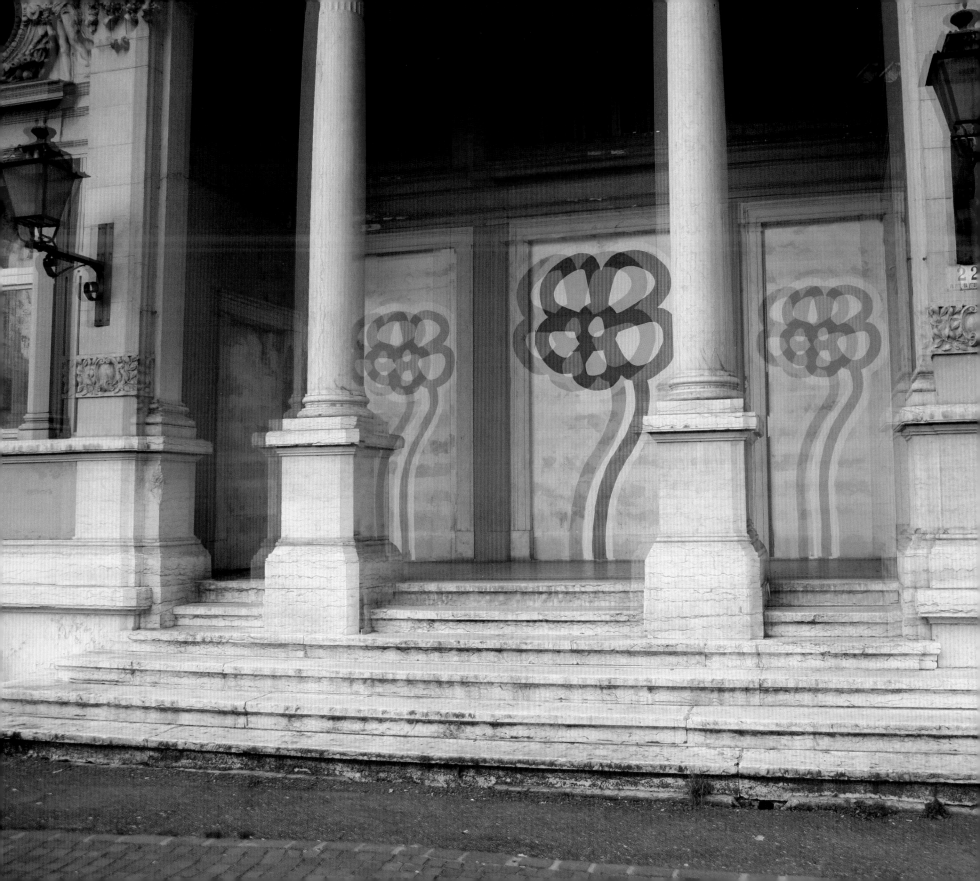

Buff Monster
*Untitled*, 2009

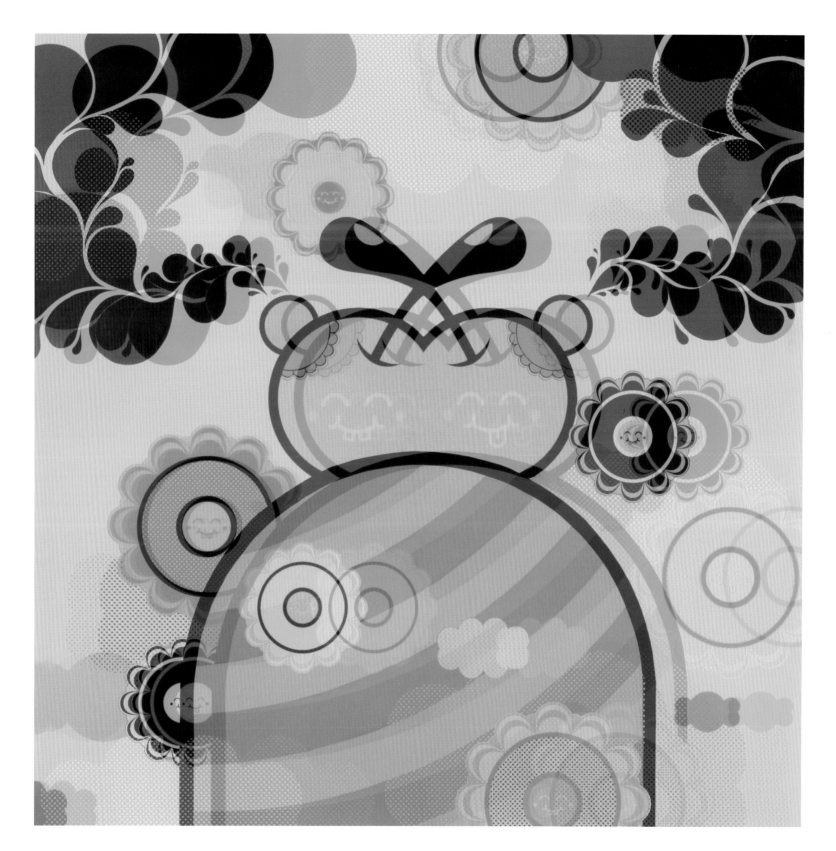

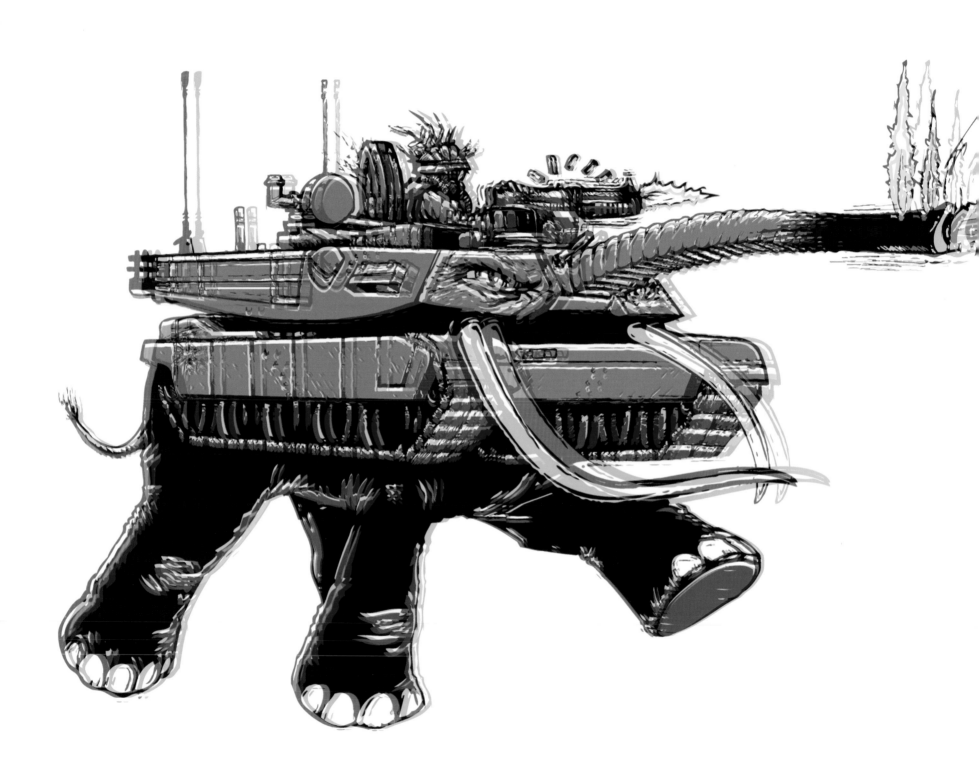

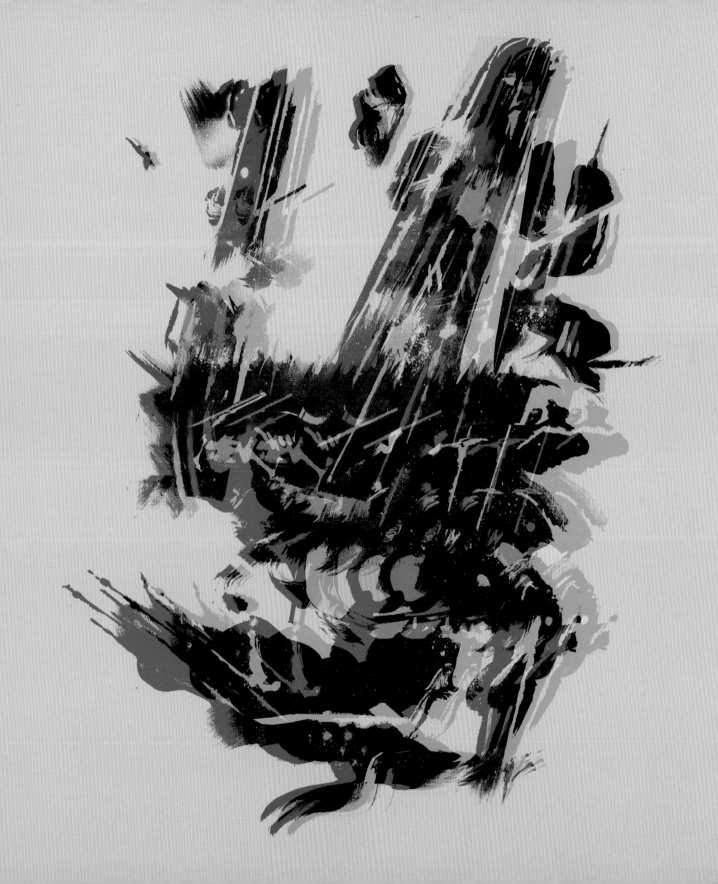

Dave Needham
*Waldo Enters the Dripping Mountains, 2009*

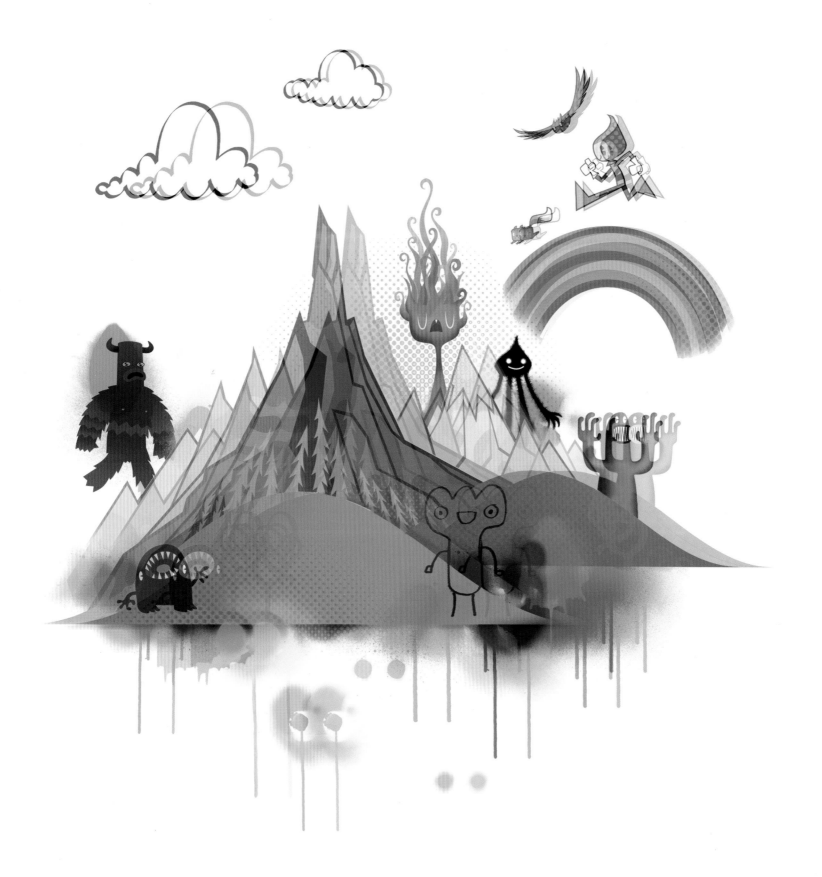

Nathan Jurevicius
*City Vision*, 2010

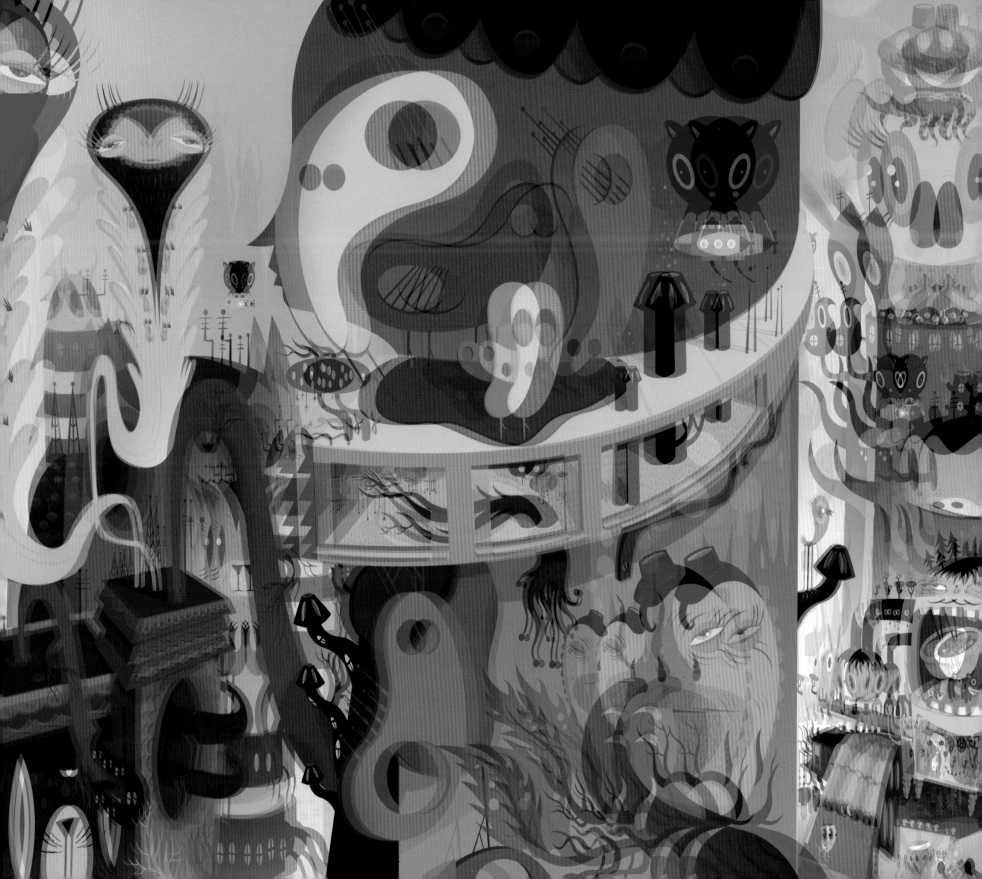

**Stash**

*Under the Eel, 2006*

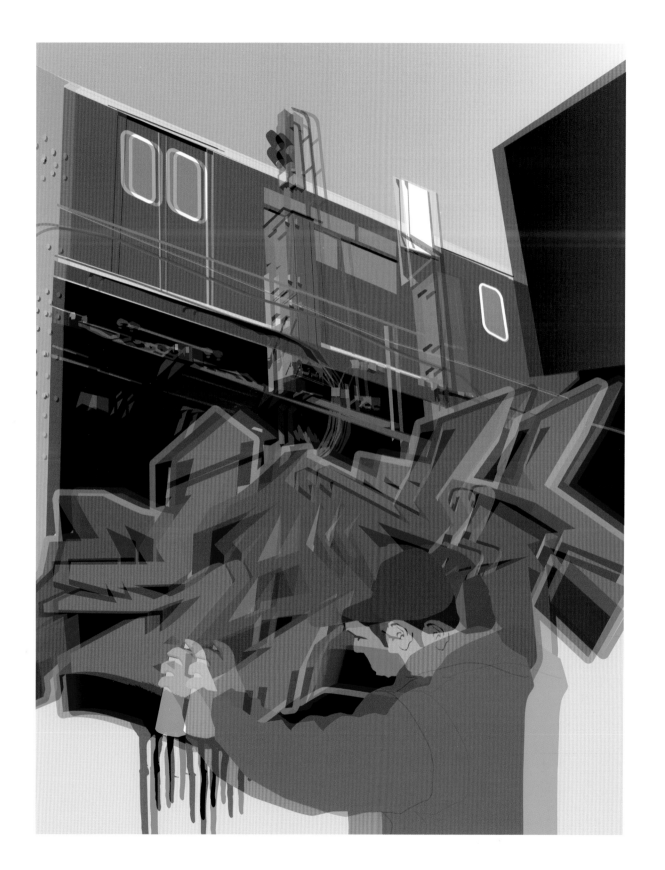

Kristian Olson
*The Correction of General Nician, 2010*

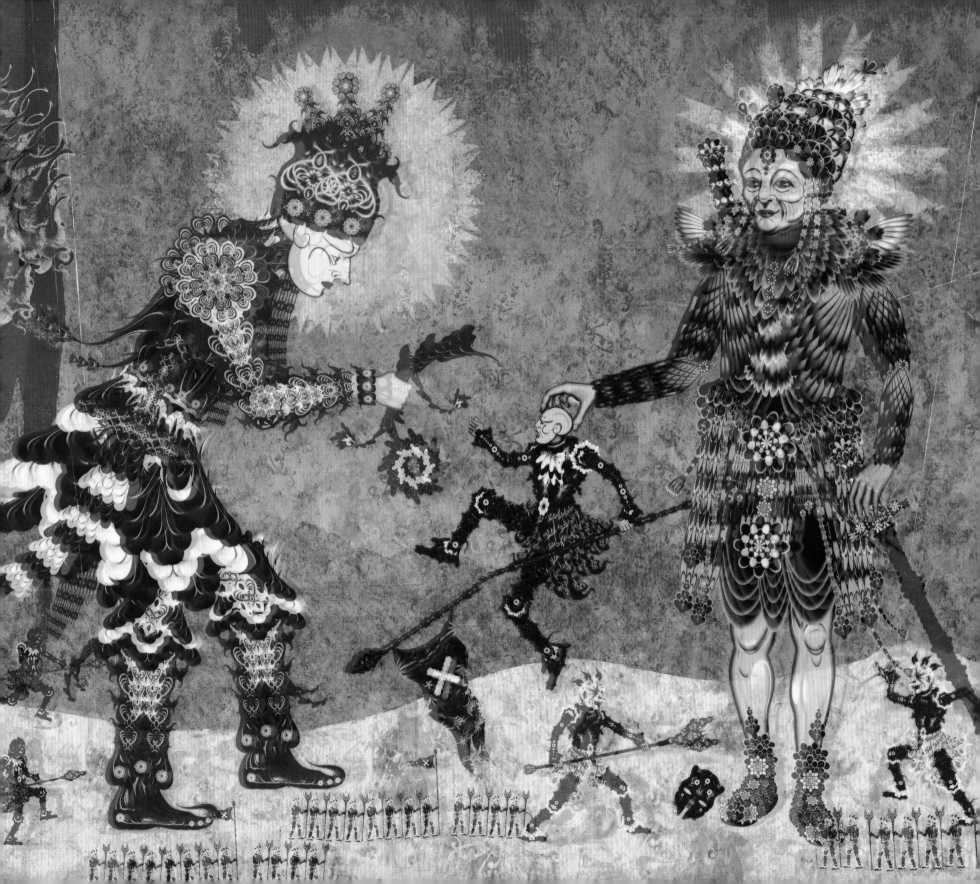

Pose MSK
*Rumble,* 2010

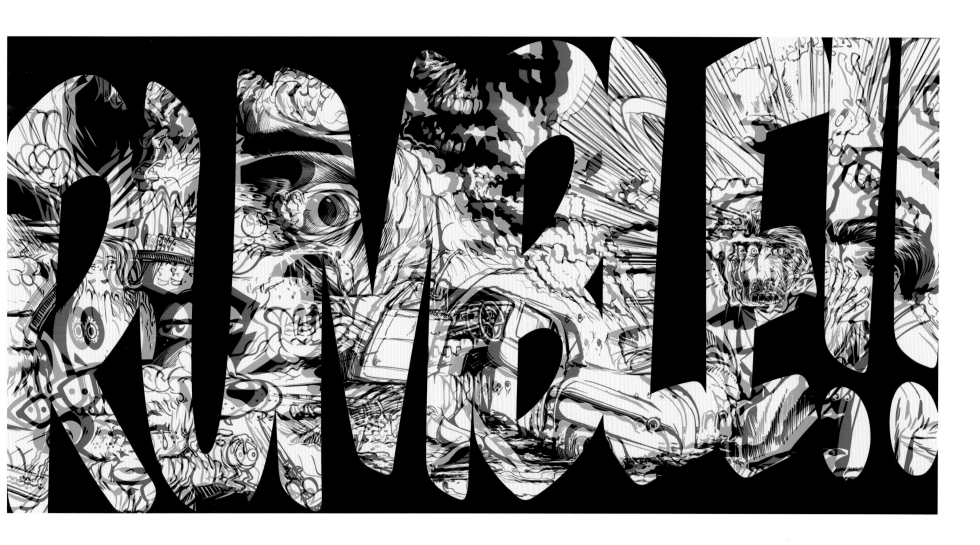

Renata Palubinskas
*Circle,* 2010

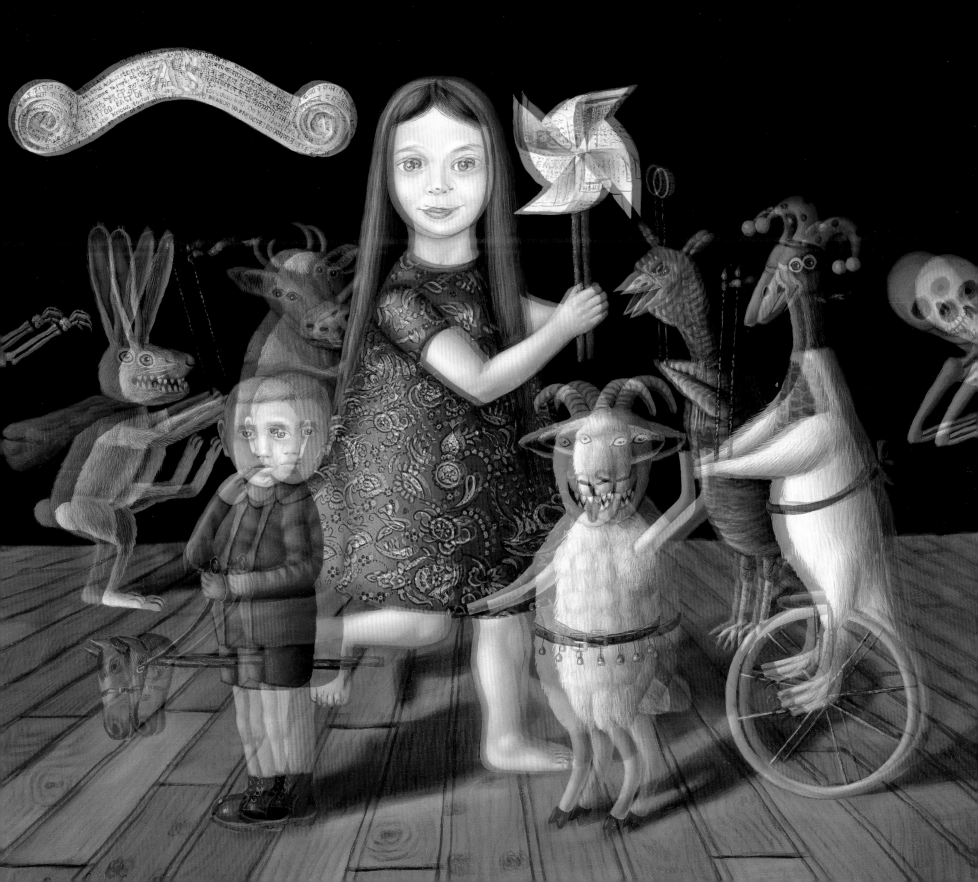

**Ray Zone**

*Dreamer, 2007*

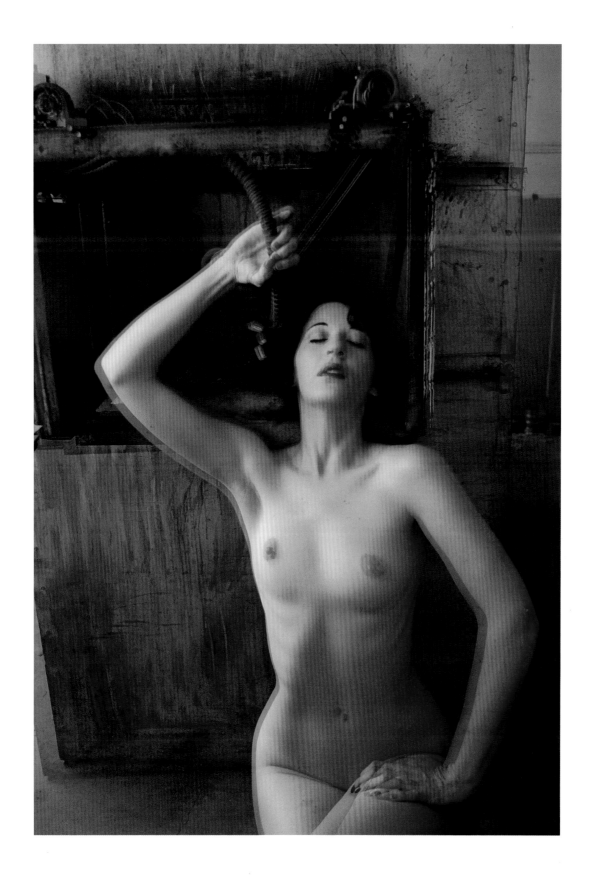

Casey Ryder (Studio Number One)
*Resisting Currents,* 2010

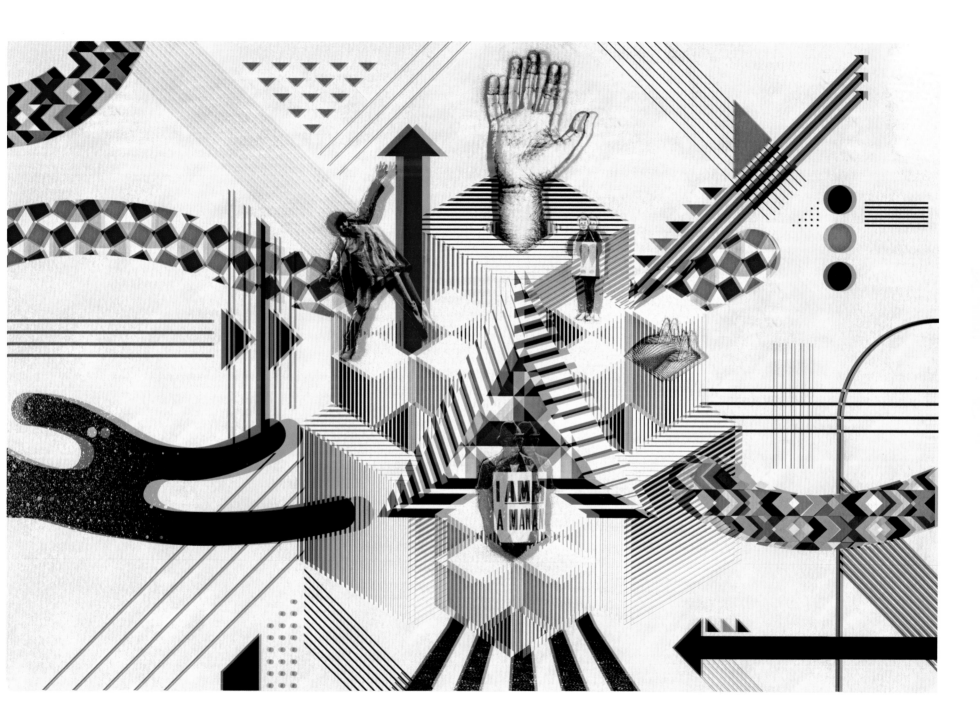

159

**Mysterious Al**
*Salboan Night God #3, 2008*

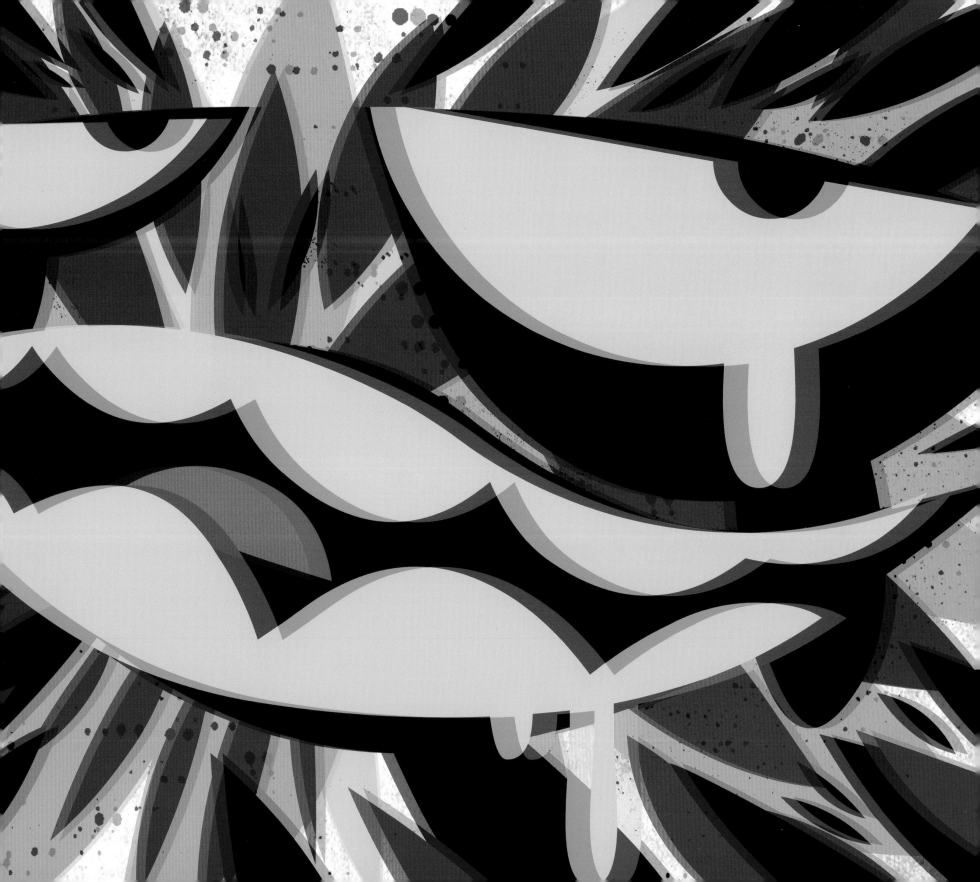

Kathy Staico Schorr

*Magician's Accomplices,* 2009

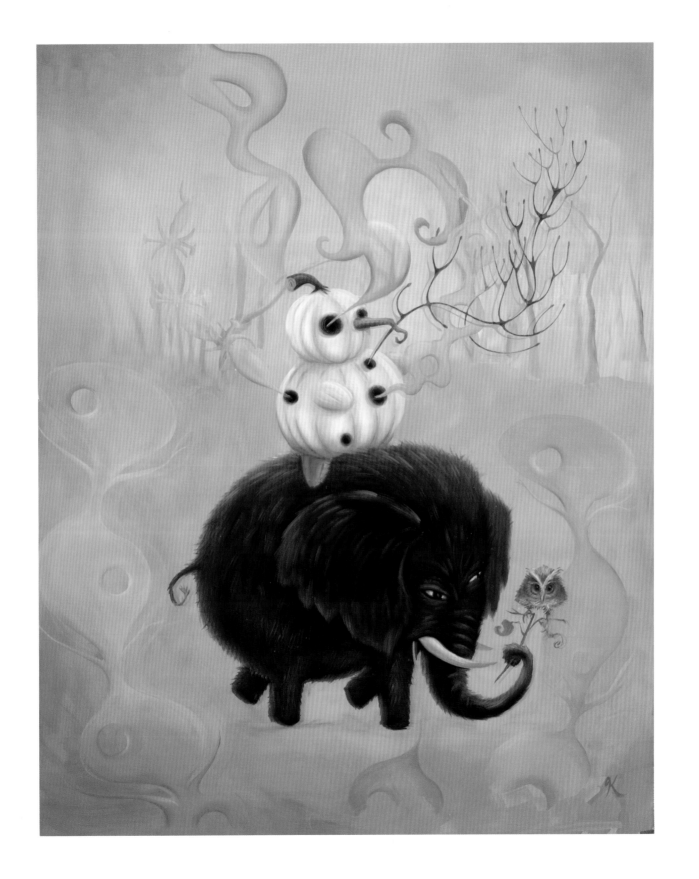

**Sket One**

*Foiled Again,* 2010

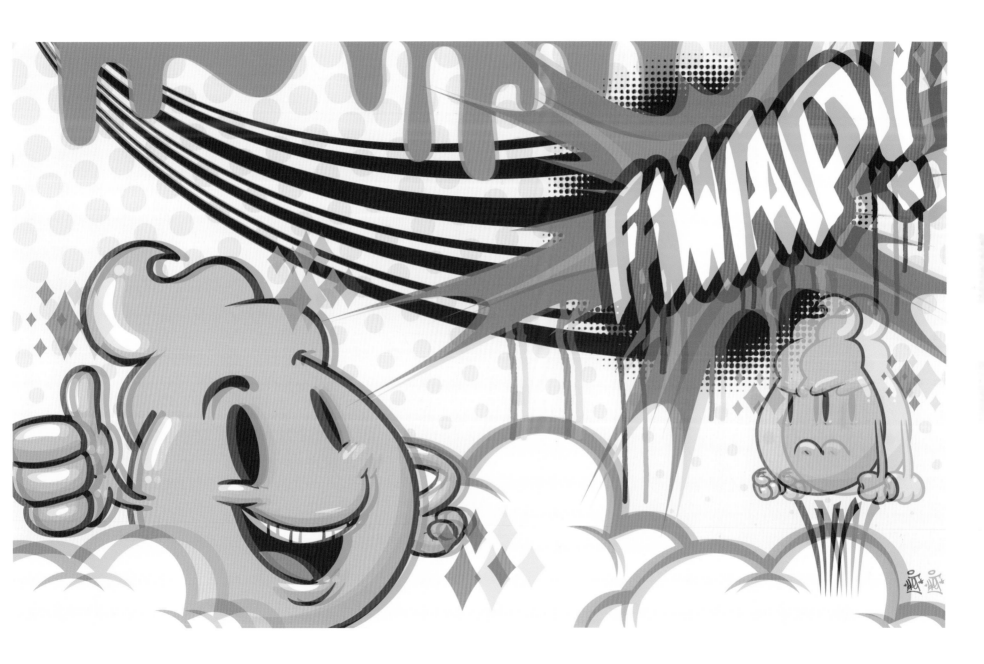

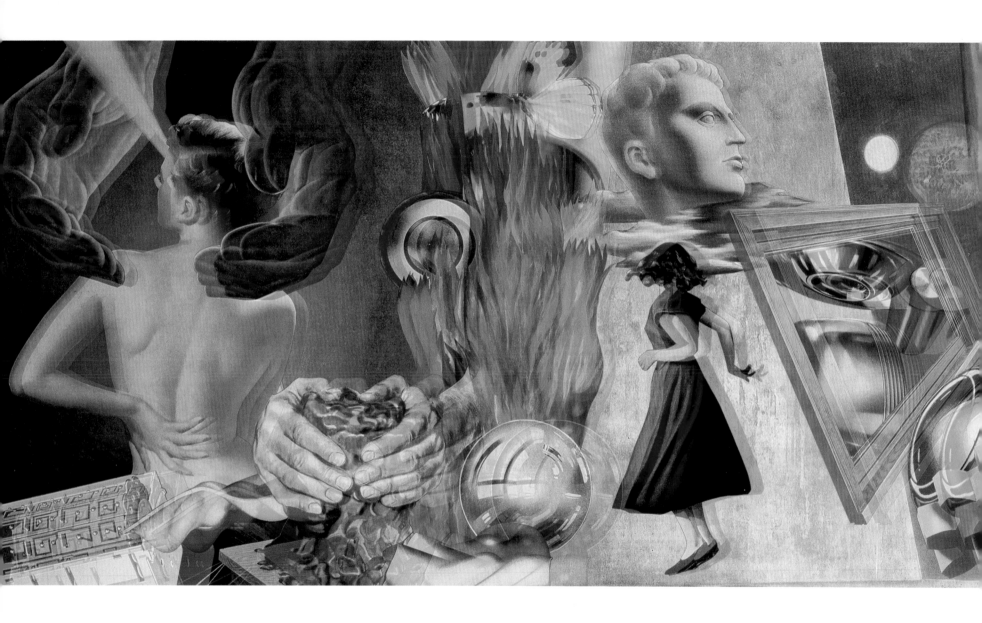

Winston Smith

*Ashes to Ashes, Dust to Dust,* 2004

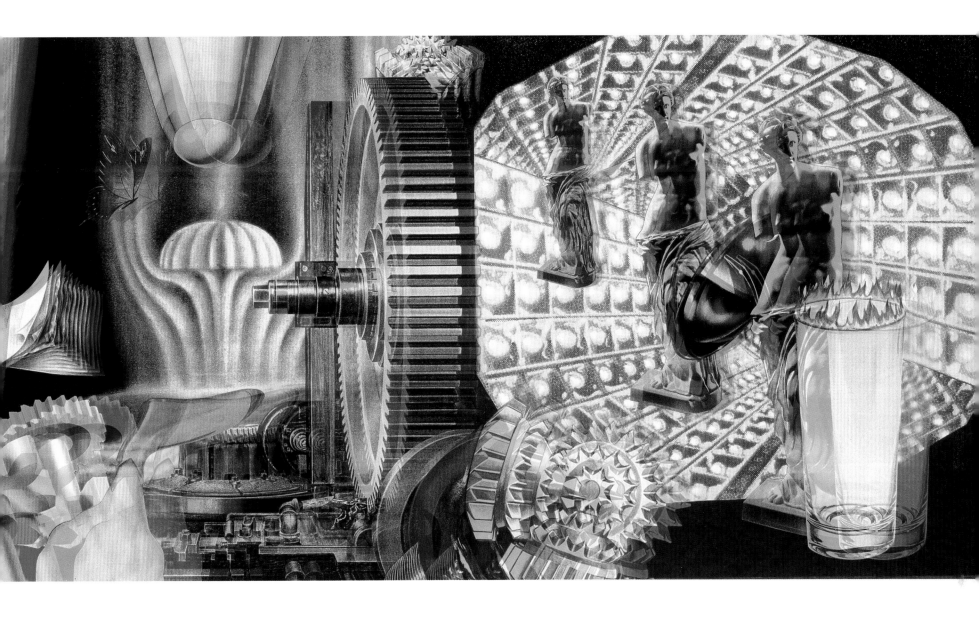

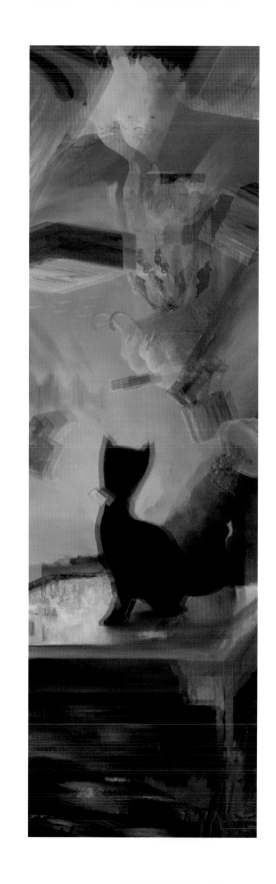

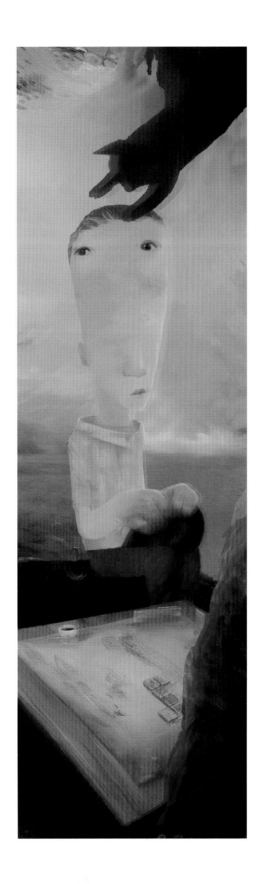

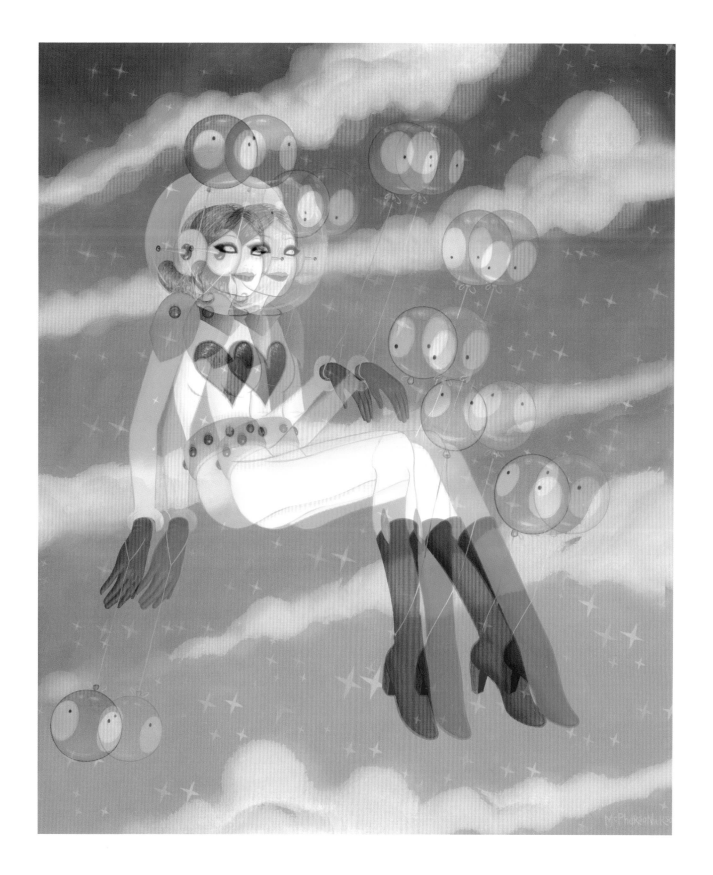

Andrew Bell

*Expedition, 2010*

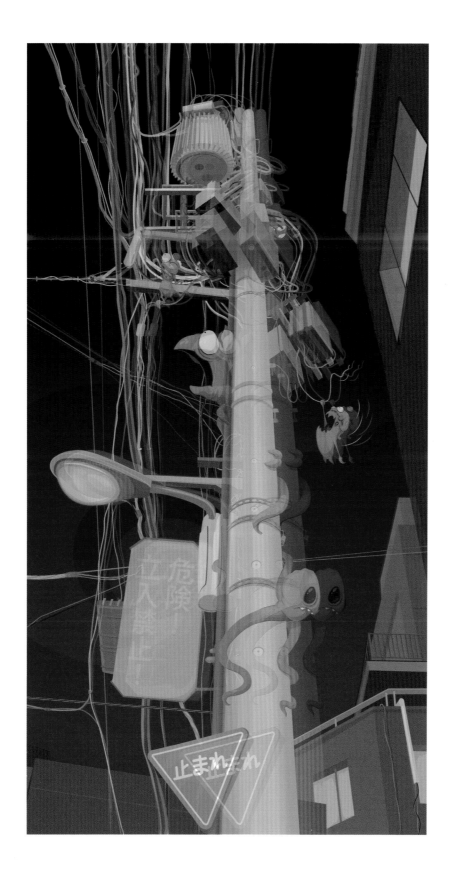

**Travis Louie**

*The Flower Sisters, 2010*

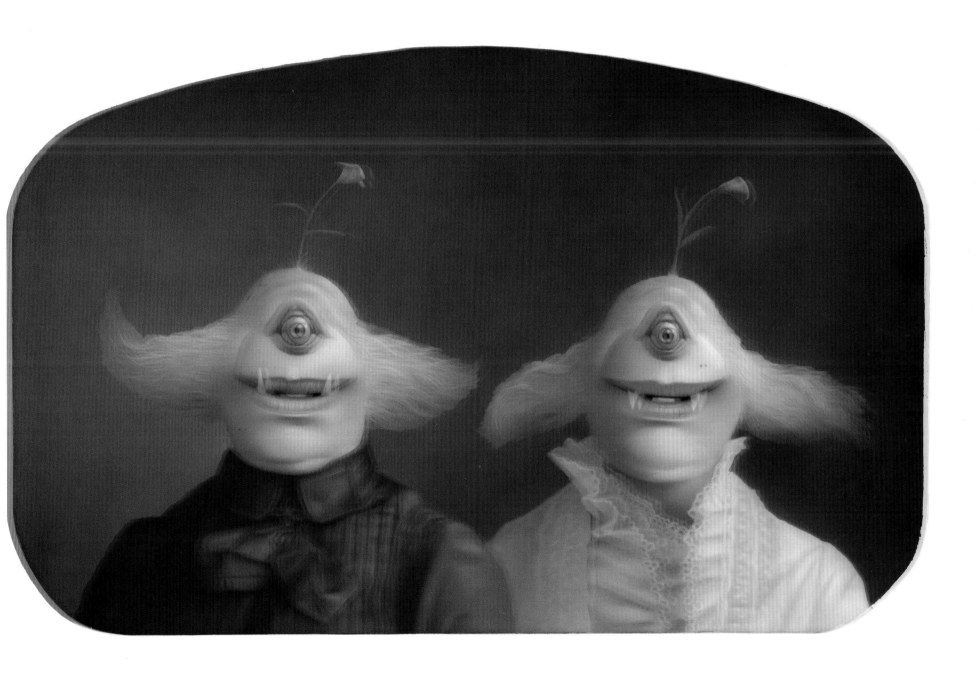

UNKL

*Untitled*, 2009

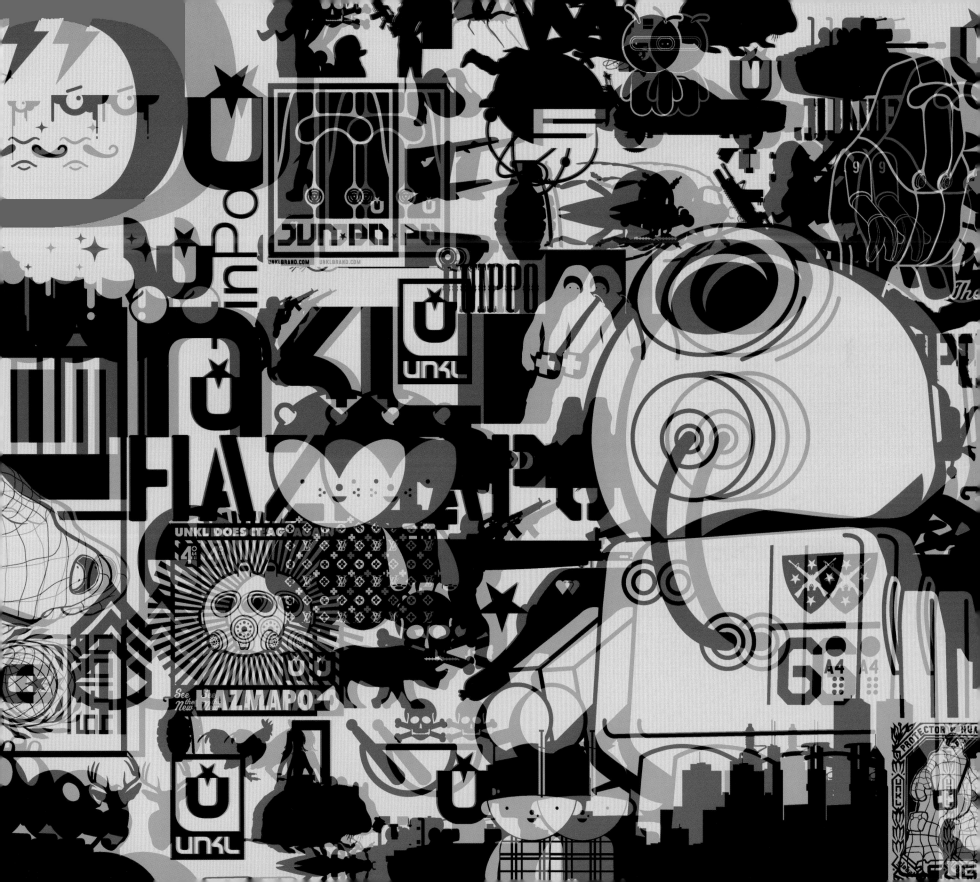

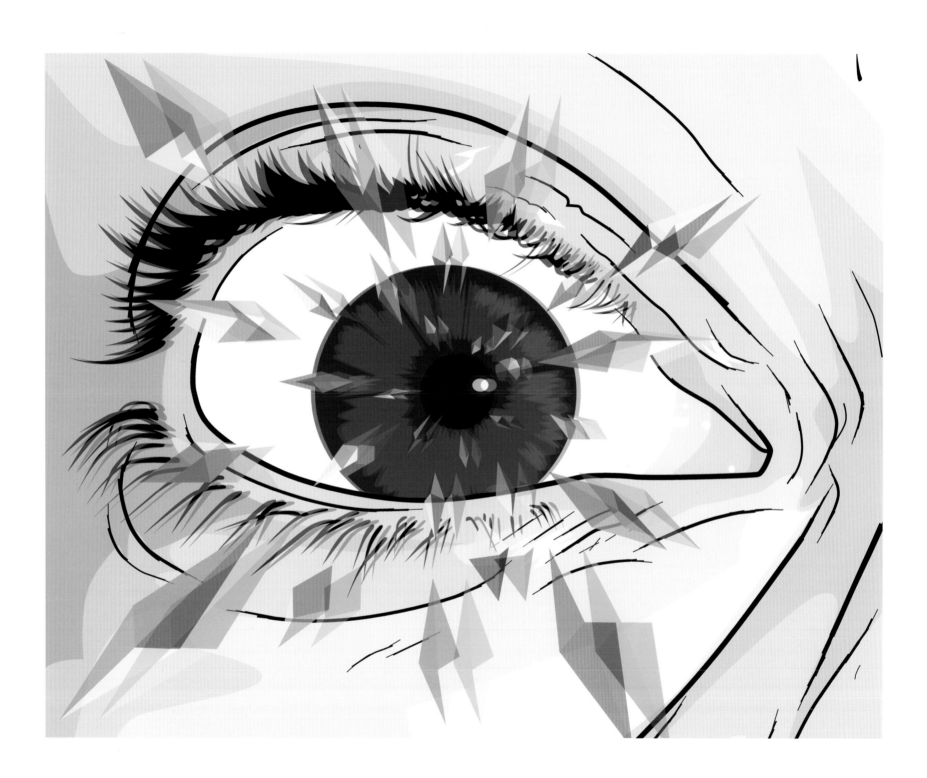

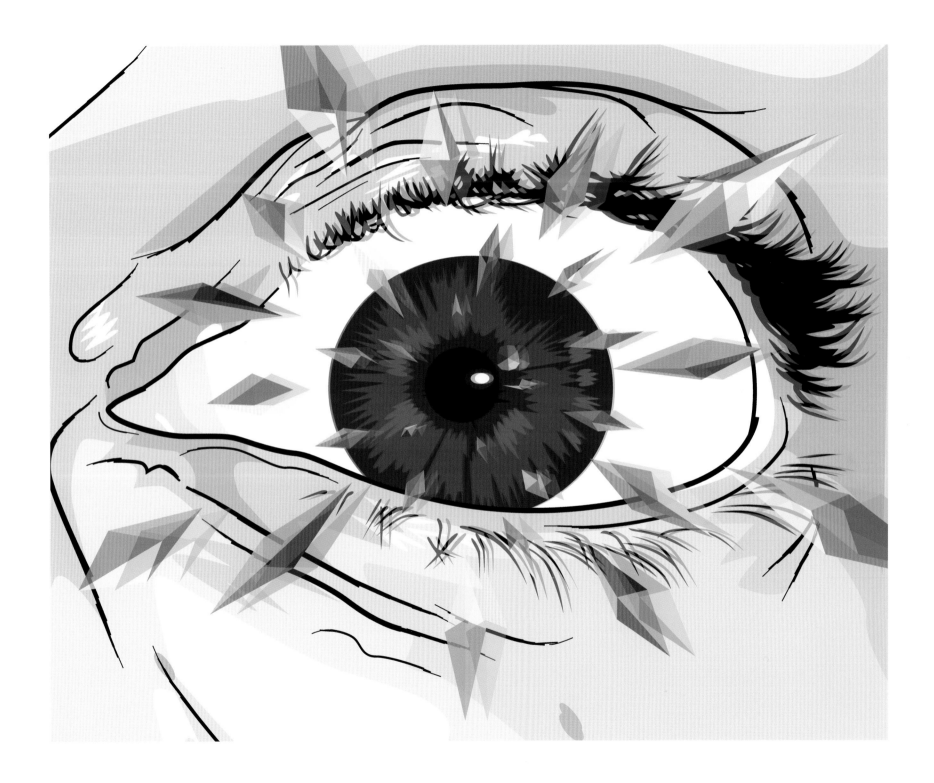

*previous spread:* **UPSO**
*Untitled,* 2009

**Julie West**
*Wilted,* 2010

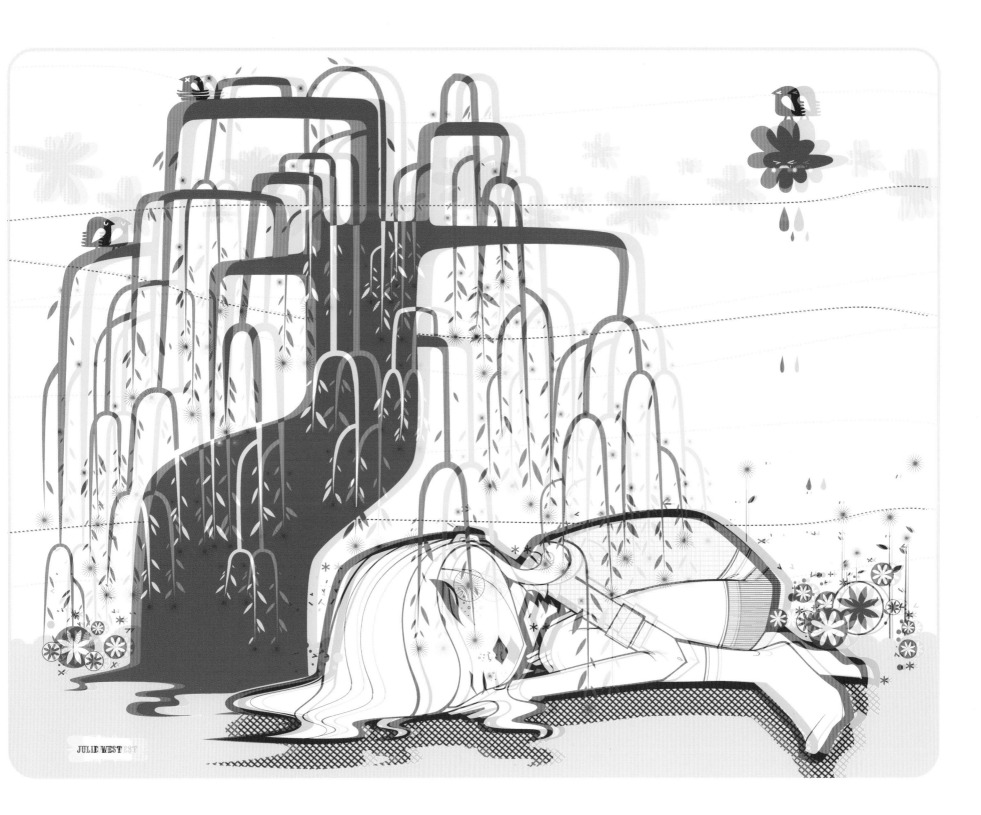

JULIE WEST

Eric White

*On the Air,* 2008

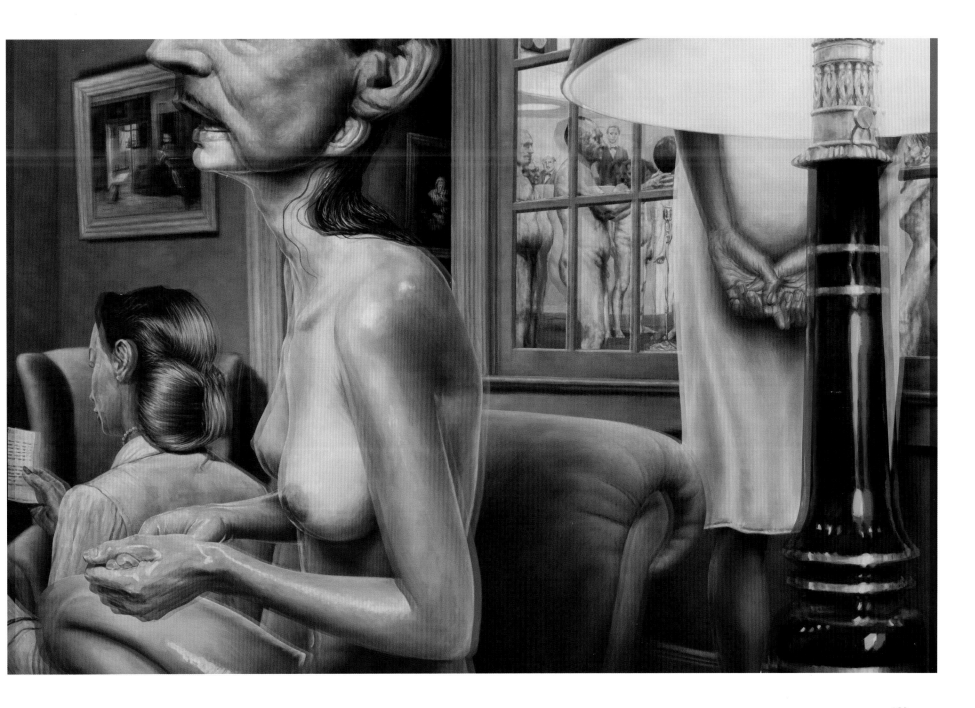

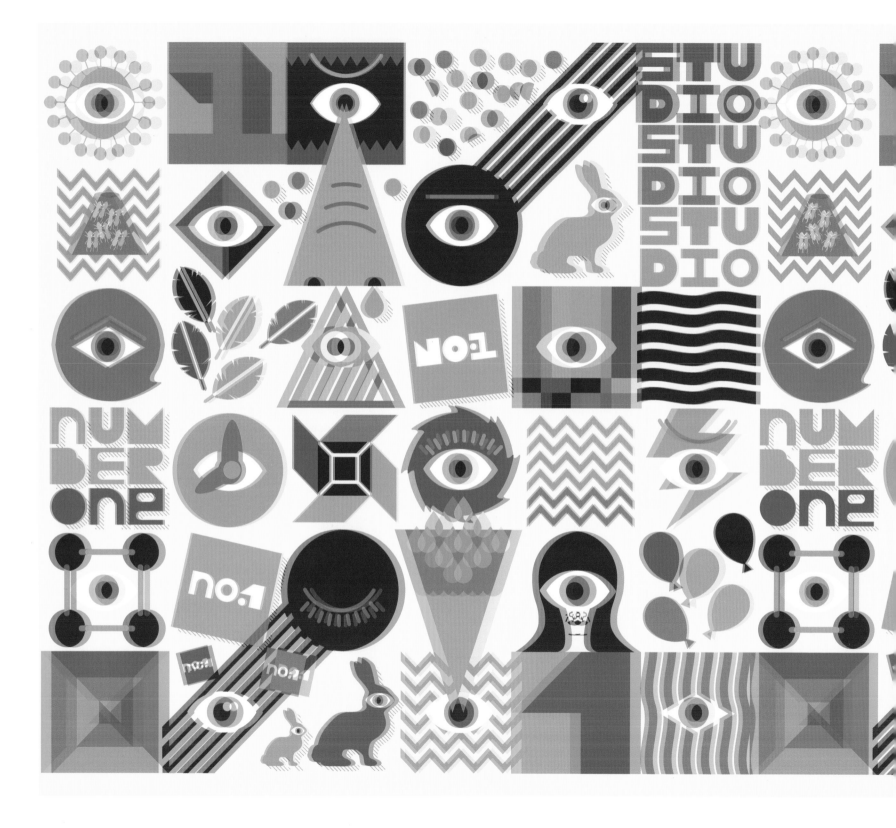

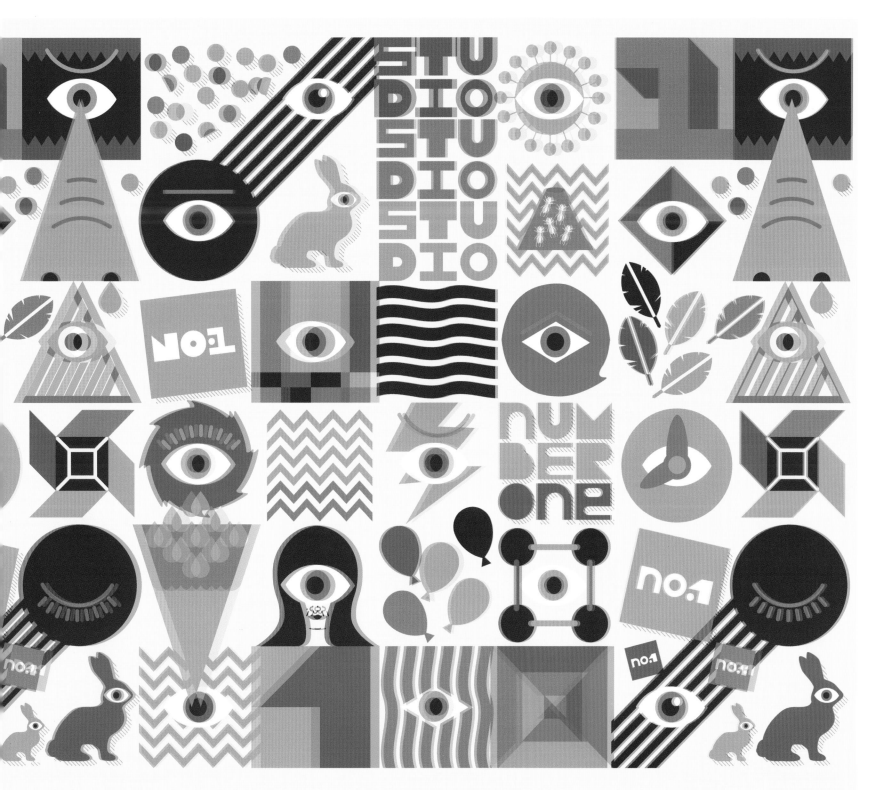

185

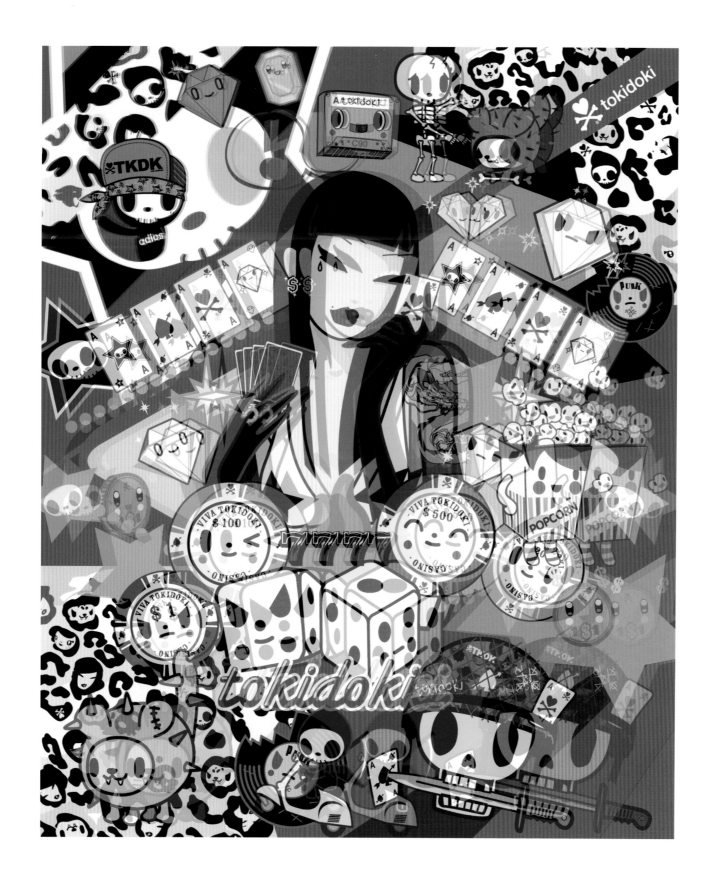

**BLOKT**

*Riot Afterparty, 2010*

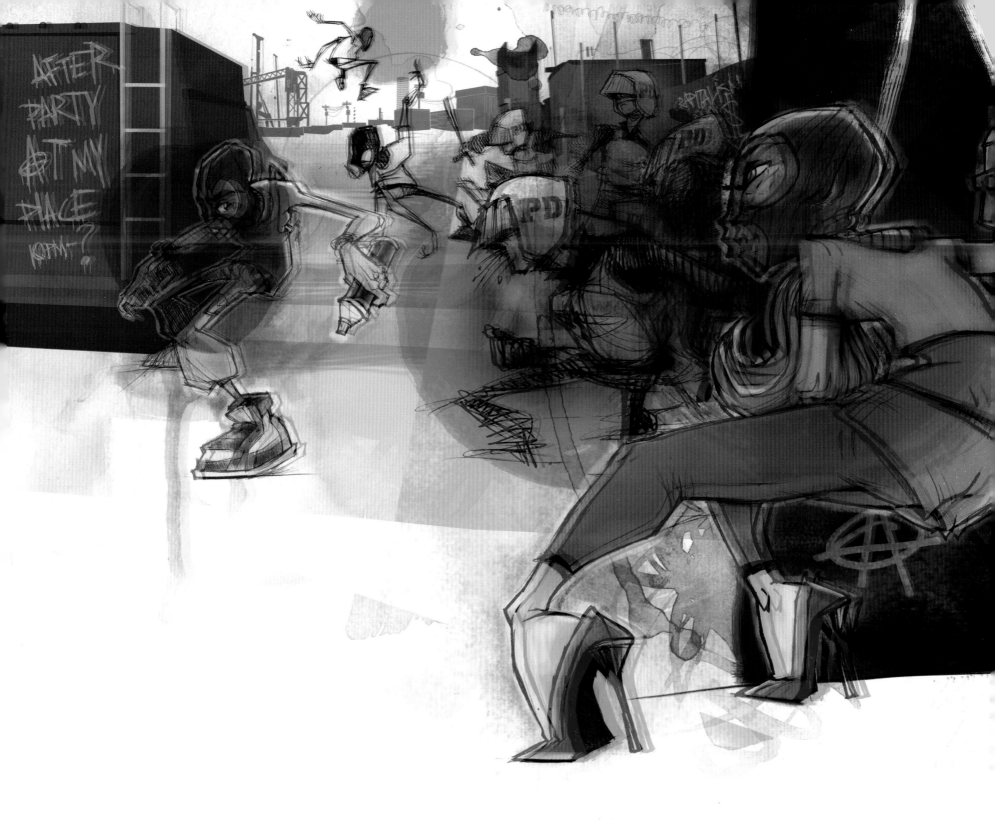

**Edatron**

*Untitled,* 2009

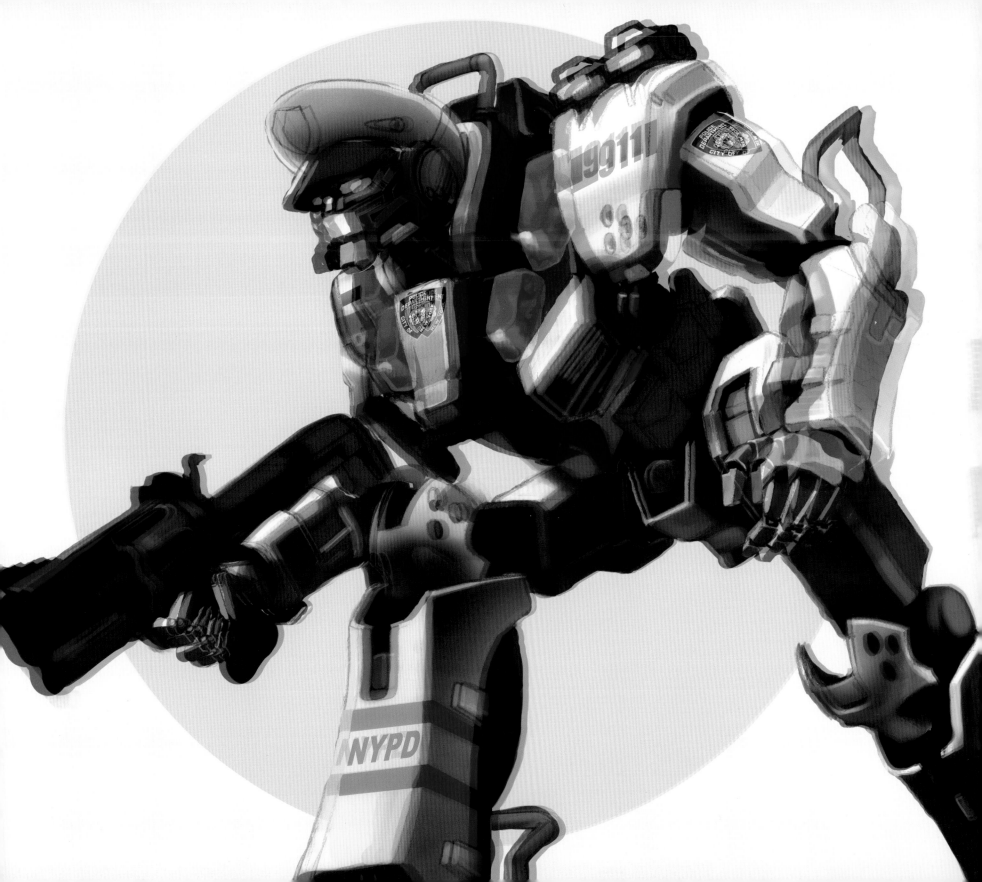

**Dalek**
*Untitled*, 2009

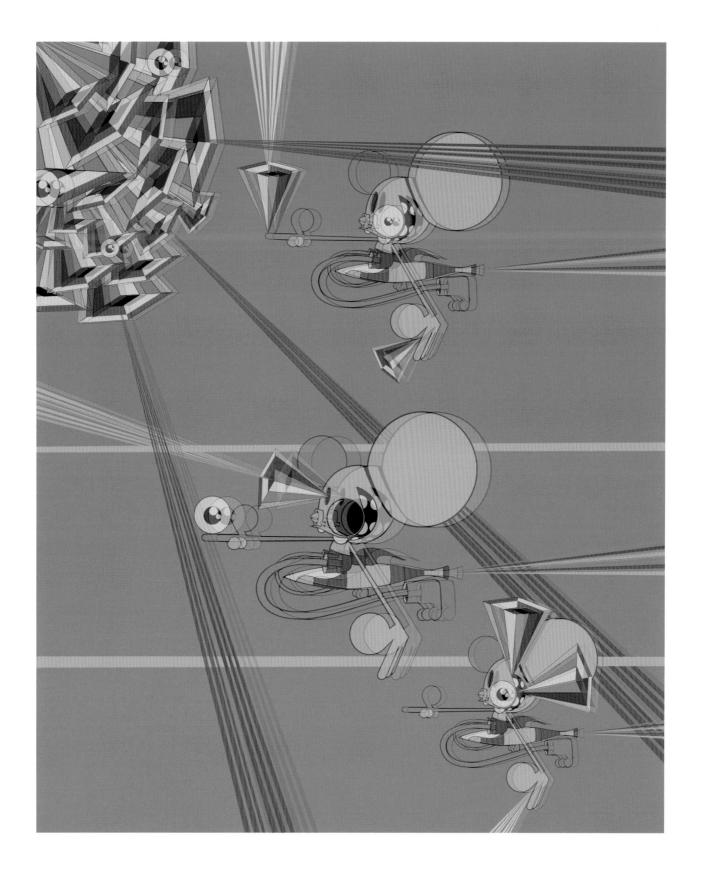

**Darren Romanelli**

*DRx Cranial Explosion, 2008*

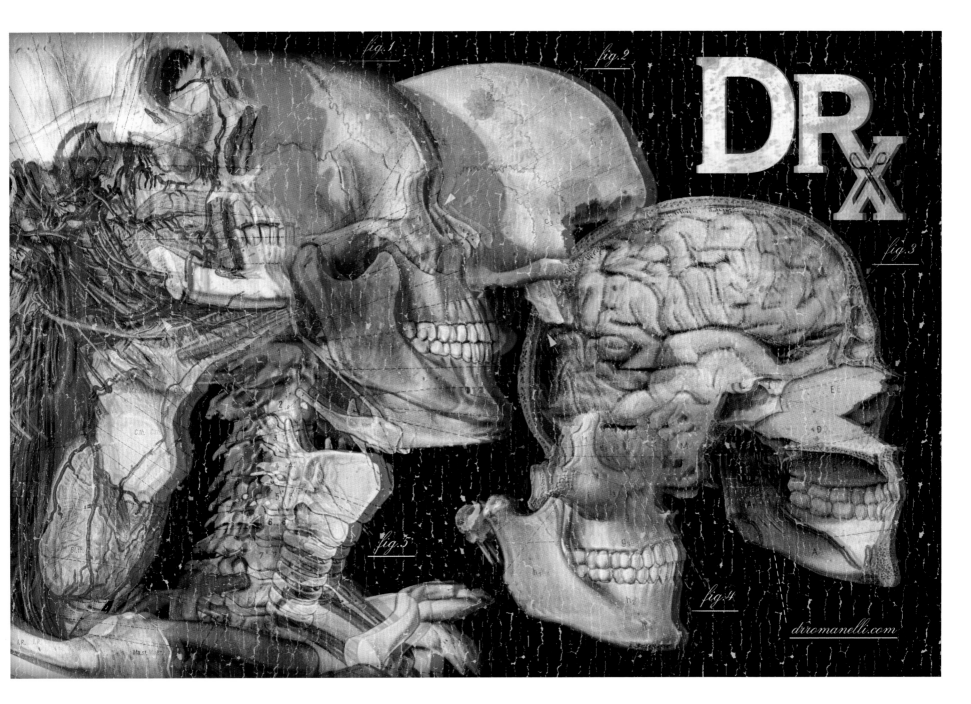

eBoy

*Baltimore, 2010*

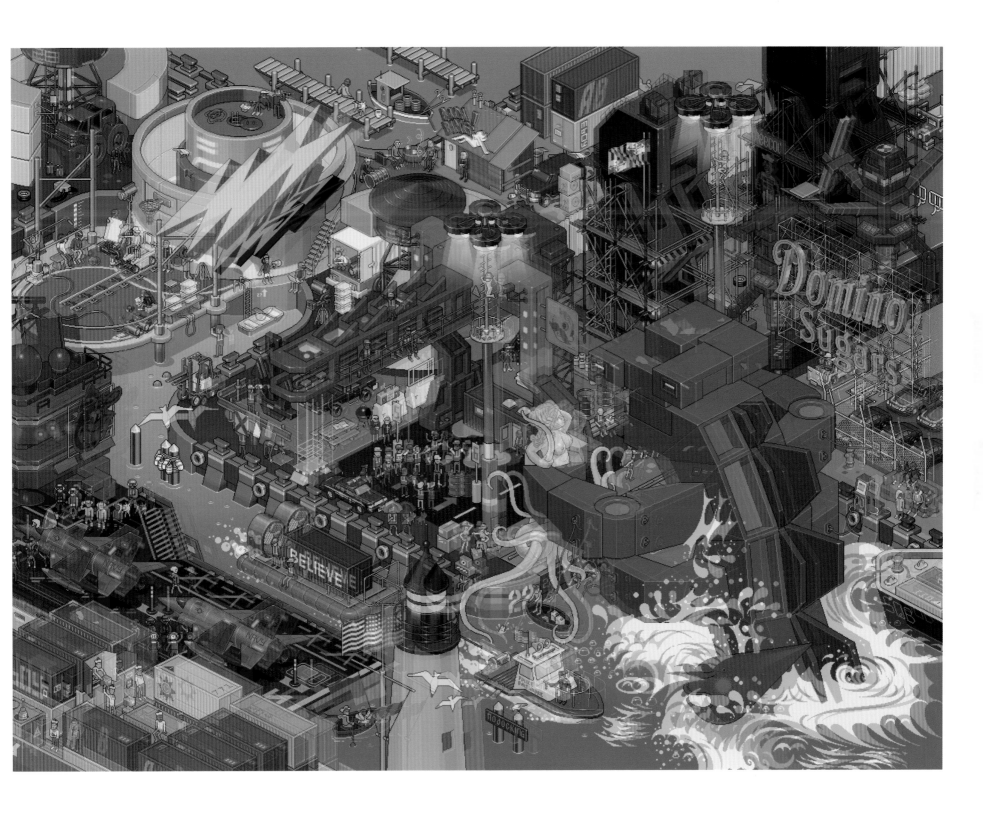

Catalina Estrada
*Clown Birds, 2010*

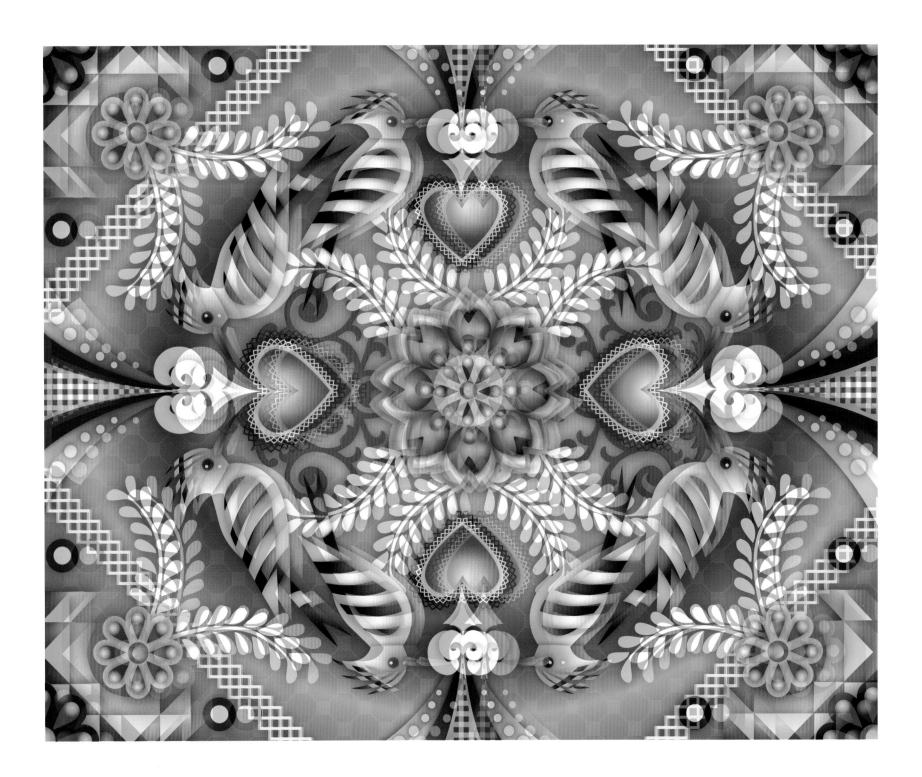

Eric Haze
*Untitled*, 2008

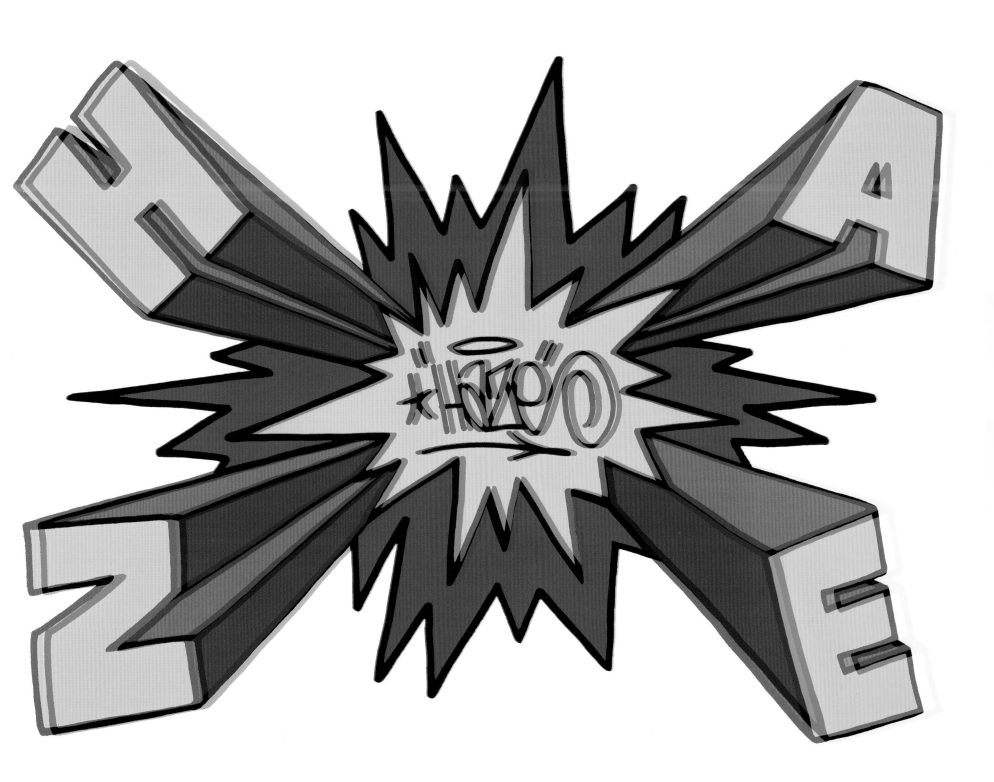

**Mishka**
*Untitled, 2010*

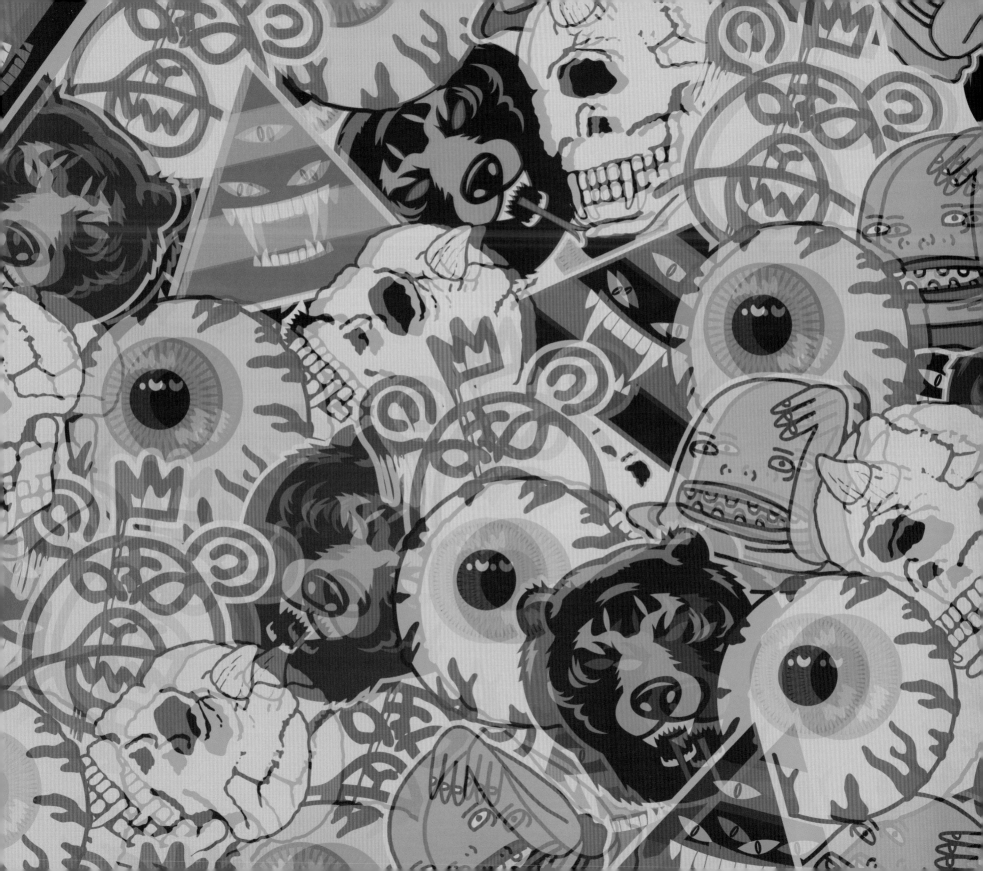

**ROSTARR**

*Odyssey for Oro Puro, 2004*

Jeremy Fish
*The Ambush*, 2009

**David Flores**

*Lee Lee, 2008*

**Erik Foss**
*American Tale,* 2010

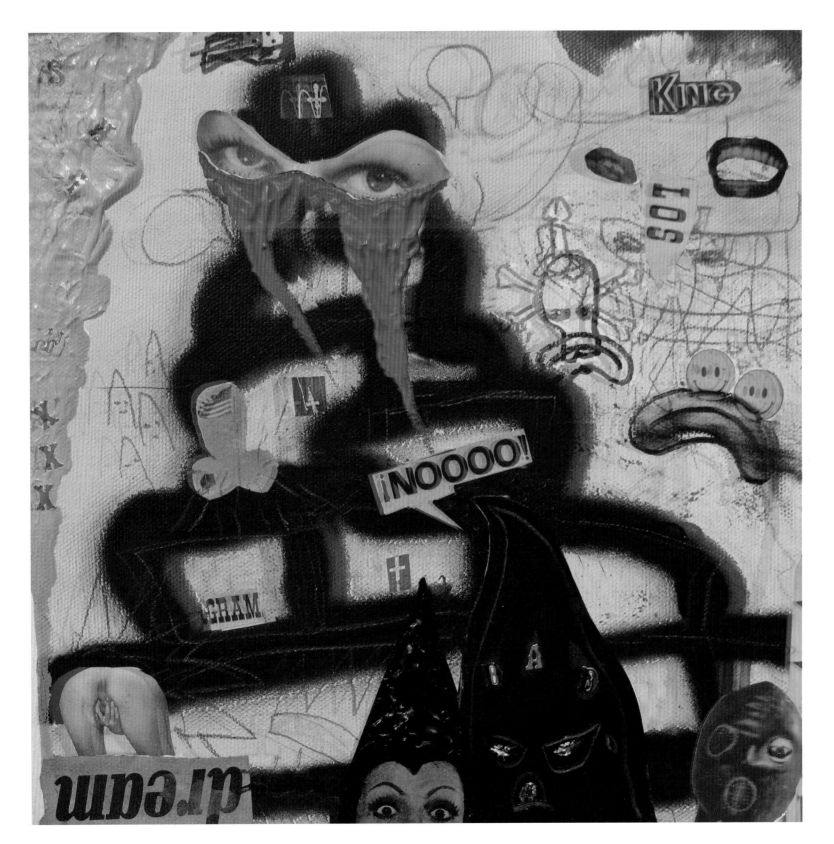

**Nathan Fox**

*Fatherhood, 2010*

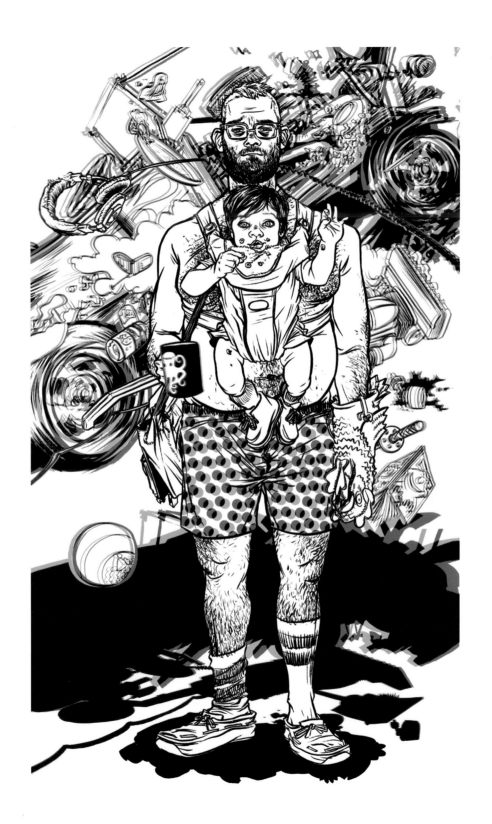

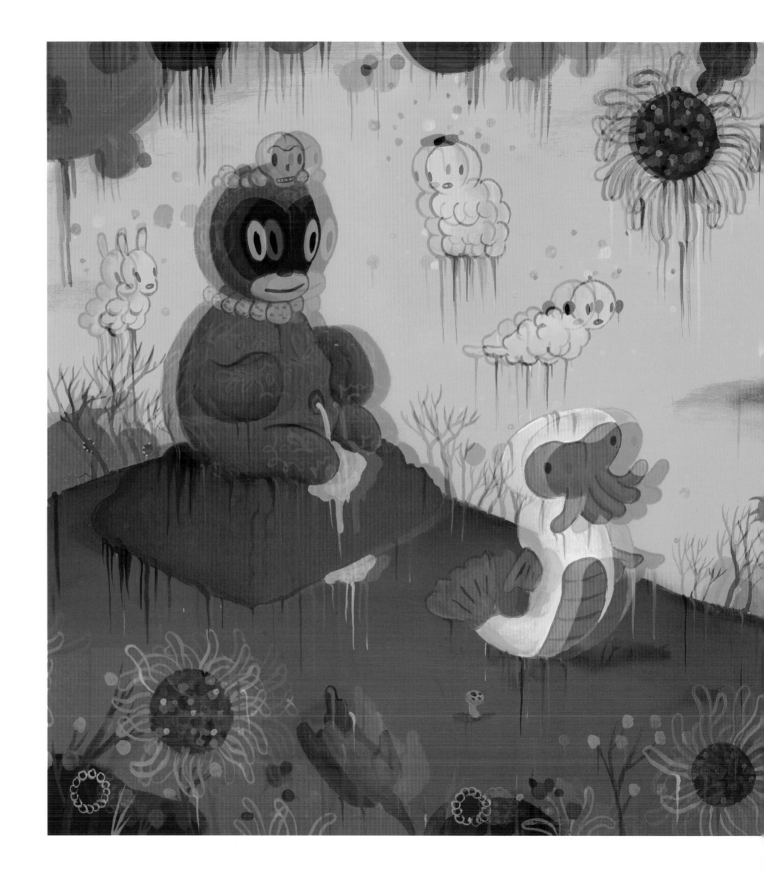

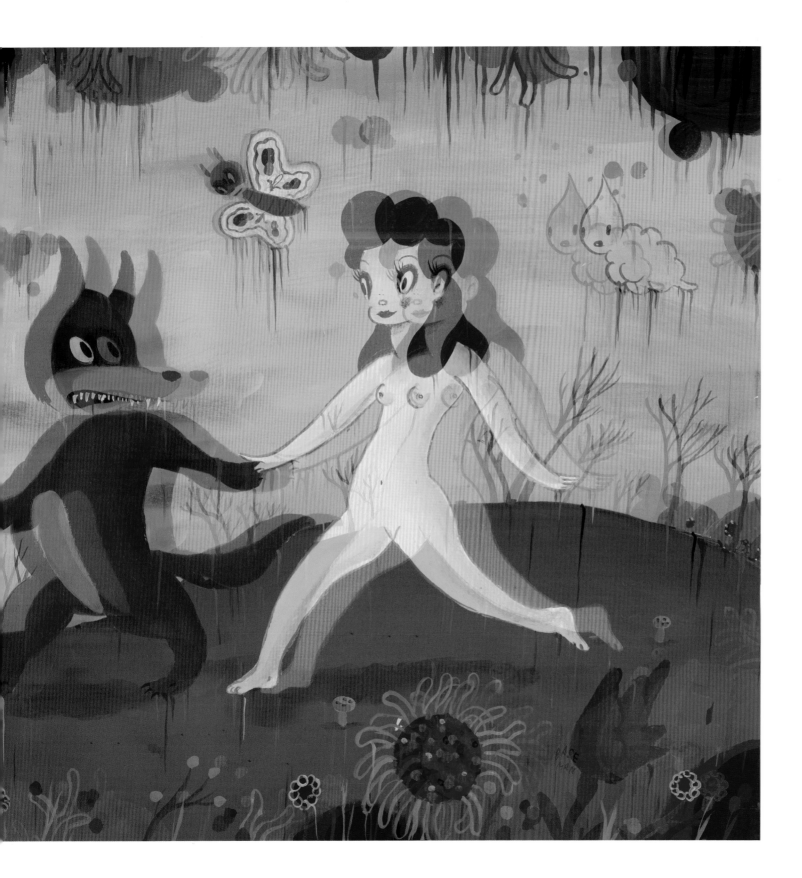

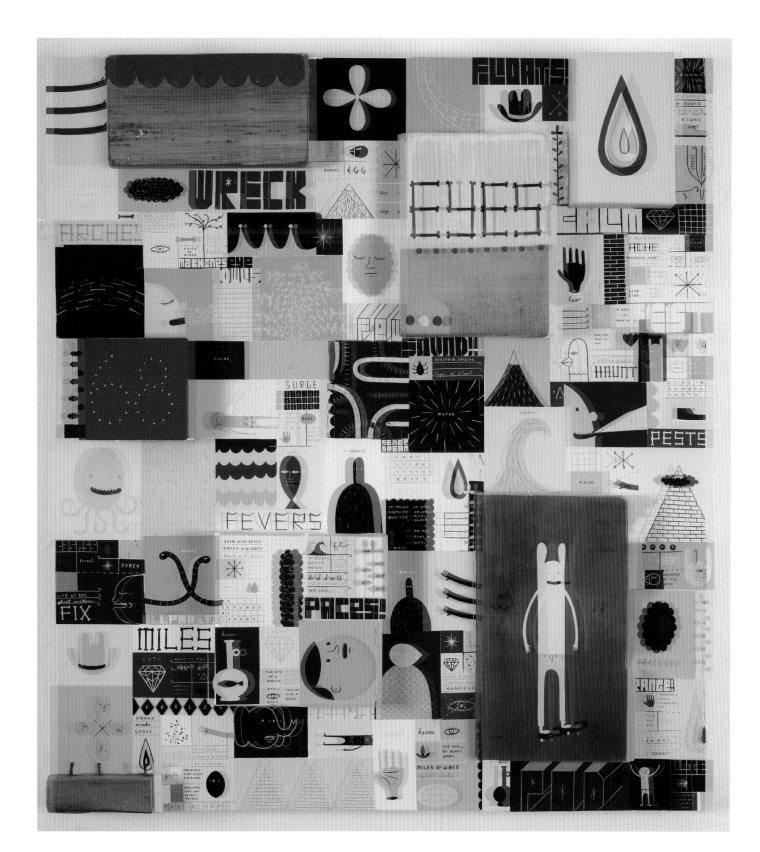

# list of illustrations

**Todd Schorr** (p. 19)
*Clowns and Crusaders*, 2002
oil on canvas
24 x 30 in.
toddschorr.com

**Askew** (p. 29)
*Diamondism in Focus Part 1*, 2010
aerosol enamel
18 x 9 in.
askew1.com

**Tes One** (p. 39)
*Flashing Lights*, 2009
acrylic on wood
12 x 8 in.
tesone.net

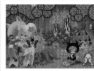
**Junko Mizuno** (p. 49)
*Volcano Party*, 2009
oil on canvas
9 x 11 in.
mizuno-junko.com

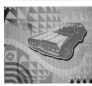
**Filth** (p. 21)
*Luxury Trim Deluxe*, 2010
digital
9 x 11 in.
filthrobotics.com

**Bask** (pp. 30, 31)
*Draw 50 Famous Cartoons*, 2010
mixed media
56 x 36 in.
knownasbask.com

**Gary Taxali** (p. 41)
*Prixy*, 2010
mixed media
15 x 20 in.
taxali.com

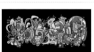
**Jon Burgerman** (pp. 50, 51)
*Untitled*, 2010
digital
20 x 10 in.
jonburgerman.com

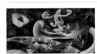
**Anthony Ausgang** (p. 23)
*The Mobius Striptease*, 2010
acrylic on canvas
17 x 8.5 in.
ausgangart.com

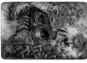
**Tom Thewes** (p. 33)
*DEMF (deLEKtrCITY)*, 1999
aerosol enamel and mixed media
36 x 48 in.
cpop.com

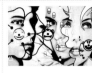
**Kevin Bourgeois** (p. 43)
*The Merchants of Cool*, 2009
mixed media
8 x 5 in.
causeycontemporary.com

**Books** (p. 53)
*Tragic Nights*, 2009
digital
24 x 36 in.
blackbookstencils.com

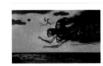
**Glenn Barr** (p. 25)
*Sibyls of the Valley*, 2008
acrylic on wood
27 x 47 in.
glbarr.com

**Stephen Bliss** (pp. 34, 35)
*The Escape from and Inevitable Return to Planet Drama*, 2008
pen and ink
9 x 22 in.
stephenbliss.com

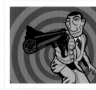
**Gomez Bueno** (p. 45)
*Juanito El Sucio*, 2009
digital
9 x 11 in.
gomezbueno.com

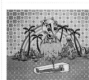
**Calma** (p. 55)
*Death is a Holiday*, 2008
acrylic on canvas
43 x 35 in.
stephandoit.com.br

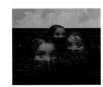
**Glenn Barr** (p. 27)
*Beckoning*, 2008
acrylic on wood
14 x 11.5 in.
glbarr.com

**Cey Adams** (p. 37)
*Cey*, 2010
aerosol enamel
20 x 10 in.
ceyadams.com

**Mint and Serf** (pp. 46, 47)
*Untitled*, 2010
giclée print
9 x 22 in.
mintandserf.com

**Mark Dean Veca** (p. 57)
*As Cold As They Come, Part II*, 2009
ink and acrylic on wood panel
24 x 36 in.
markdeanveca.com

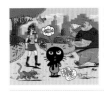
**Matt Campbell** (p. 59)
*Sad Seal*, 2008
pen and ink
9 x 11 in.
areyouexcited.com

**Esao Andrews** (p. 73)
*Quilted Sails*, 2010
oil on board
20 x 30 in.
esao.net

**Shepard Fairey** (p. 87)
*Two Sides of Capitalism: Bad*, 2007
mixed media on canvas
13.5 x 8 in.
obeygiant.com

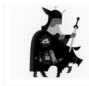
**Adrian Johnson** (p. 101)
*Untitled*, 2010
digital
11 x 9 in.
adrianjohnson.org.uk

**Stanley Chow** (p. 61)
*Welcome to Manchester*, 2010
digital
11 x 9 in.
stanleychow.co.uk

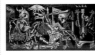
**Ron English** (pp. 74, 75)
*X-Ray Division*, 2010
oil on wood
90 x 45 in.
popaganda.com

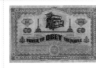
**Shepard Fairey** (p. 89)
*Two Sides of Capitalism: Good*, 2007
mixed media on wall
10 x 30 in.
obeygiant.com

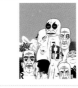
**Dave Kinsey** (p. 103)
*Inhumanate*, 2008
screen print
18 x 24 in.
kinseyvisual.com

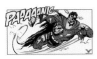
**D*Face** (p. 63)
*Dead Superman*, 2010
digital
18 x 30 in.
dface.co.uk

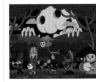
**Pete Fowler** (p. 77)
*Untitled*, 2010
digital
12 x 10 in.
monsterism.net

**Jerry Abstract** (p. 91)
*Untitled*, 2008
digital
9 x 9 in.
jerryabstract.com

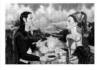
**Laura Barnhard** (p. 105)
*Social Restraint*, 2006
oil on canvas
24 x 36 in.
laurabarnhard.com

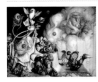
**Craola** (p. 65)
*The Pearl Thief*, 2010
acrylic on canvas
72 x 96 in.
imscared.com

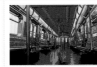
**Logan Hicks** (p. 79)
*Steel Reflecting Pool*, 2010
spray paint on cardboard
48 x 36 in.
workhorsevisuals.com

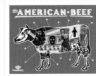
**TrustoCorp** (p. 93)
*American Beef*, 2010
digital
86 x 64 in.
trustocorp.com

**kaNO** (pp. 106, 107)
*Duck Season, Rabbit Season*, 2010
digital
8 x 10 in.
kanokid.com

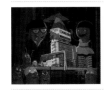
**Dabs and Myla** (p. 67)
*Super Fantastic*, 2010
acrylic on wood
22 x 18 in.
dabsmyla.com

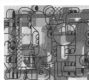
**DEMO** (p. 81)
*Untitled*, 2009
digital
9 x 11 in.
demo-design.com

**Rich Jacobs** (p. 95)
*Alone, Even in a Crowd*, 2010
ink on paper
9 x 11 in.
mywebsiteisinyourmind.com

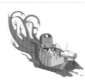
**Kevin Skinner** (p. 109)
*The Mourning Show*, 2010
digital
11 x 9 in.
budgetraygun.com

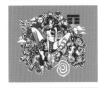
**Tristan Eaton** (p. 69)
*Wild Beauty*, 2009
digital
9 x 9 in.
tristaneaton.net

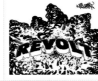
**Dr. Revolt** (p. 83)
*Untitled*, 2010
digital
11 x 9 in.
nytrash.com/Revolt.html

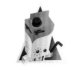
**Mark James** (p. 97)
*Cardboy Orange*, 2010
digital
9 x 9 in.
cardboy.tv

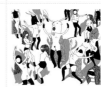
**Kid Acne** (p. 111)
*Dance Night*, 2010
pen and ink
11 x 9 in.
kidacne.com

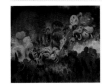
**Dave Cooper** (p. 71)
*Arm of Hosts*, 2008
oil on canvas
7 x 4 in.
davegraphics.com

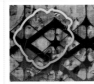
**Matt Eaton** (p. 85)
*Loaf*, 2010
aerosol enamel and acrylic on wood
24 x 24 in.
xiiiv.com

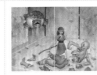
**James Jean** (p. 99)
*Shattered*, 2008
pastel on paper
41 x 60 in.
jamesjean.com

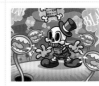
**Jeremy Madl** (p. 113)
*Modern Hero*, 2008
digital
11 x 9 in.
madtoydesign.com

 **Kenzo Minami** (pp. 114, 115)
*Chambre Avec Vue*, 2010
digital
22 x 9 in.
kenzominami.com

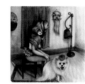 **Miss Van** (p. 129)
*Mascaras 4*, 2010
acrylic on canvas
45 x 45 in.
missvan.com

 **Mr Jago** (p. 143)
*Citizen*, 2010
acrylic on paper
23 x 16.5 in.
mrjago.com

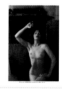 **Ray Zone** (p. 157)
*Dreamer*, 2007
stereo photograph
6 x 9 in.
ray3dzone.com

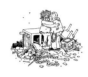 **Travis Millard** (p. 117)
*Hug It Out*, 2009
ink on paper
11 x 9 in.
fudgefactorycomics.com

 **Maya Hayuk** (p. 131)
*A Path for the Light*, 2009
acrylic and ink on paper
38 x 50 in.
mayahayuk.com

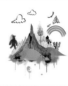 **Dave Needham** (p. 145)
*Waldo Enters the Dripping Mountains*, 2009
digital
13 x 13 in.
ba-reps.com

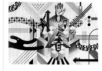 **Casey Ryder (Studio Number One)** (p. 159)
*Resisting Currents*, 2010
mixed media
9 x 13 in.
mynameiscasey.com

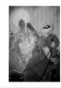 **Mark Bode** (p. 119)
*Cobalt 60*, 2010
acrylic on canvas
24 x 36 in.
markbode.com

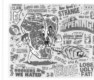 **Morning Breath** (p. 133)
*Steaks are High*, 2010
ink and collage
11 x 9 in.
morningbreathinc.com

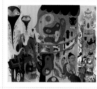 **Nathan Jurevicius** (p. 147)
*City Vision*, 2010
digital
9 x 11 in.
nathanj.com.au

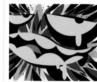 **Mysterious Al** (p. 161)
*Salboan Night God #3*, 2008
digital
11 x 9 in.
mysteriousal.com

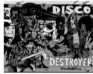 **Jim Mahfood** (p. 121)
*Disco Destroyer*, 2010
digital
9 x 11 in.
40ozcomics.com

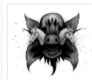 **Jeff Soto** (p. 135)
*Untitled*, 2010
acrylic on board
13 x 10.5 in.
jeffsoto.com

 **Stash** (p. 149)
*Under the Eel*, 2006
digital
8 x 10 in.
wesc.com

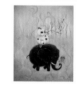 **Kathy Staico Schorr** (p. 163)
*Magician's Accomplices*, 2009
oil on panel
9 x 11 in.
kathystaicoschorr.com

 **Mark Ryden** (p. 123)
*The Magic Circus*, 2001
oil on canvas
40 x 60 in.
markryden.com

 **Michael De Feo** (p. 137)
*Untitled*, 2008
wheatpaste on wall
14 x 7 ft.
mdefeo.com

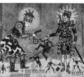 **Kristian Olson** (p. 151)
*The Correction of General Nician*, 2010
digital
18 x 11 in.
kristianolson.com

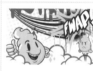 **Sket One** (p. 165)
*Foiled Again*, 2010
digital
11 x 18 in.
sket-one.com

 **Bill McMullen** (pp. 124, 125)
*Never Breathe a Word About Your Loss*, 2010
digital
22 x 9 in.
billmcmullen.com

 **Buff Monster** (p. 139)
*Untitled*, 2009
acrylic on wood
30 x 30 in.
buffmonster.com

 **Pose MSK** (p. 153)
*Rumble*, 2010
ink on paper
25 x 15 in.
wearesupervision.com

 **Winston Smith** (pp. 166, 167)
*Ashes to Ashes, Dust to Dust*, 2004
mixed media,
17.5 x 4.5 in.
winstonsmith.com

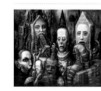 **Chris Mars** (p. 127)
*Healing by Way of the Ace of Blurred Matter*, 2009
oil on panel
18 x 22 in.
chrismarspublishing.com

 **Kobie Solomon** (pp. 140, 141)
*Pachyndeath*, 2006
pen and ink
11 x 17 in.
graffiticoloringbook.com

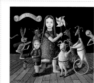 **Renata Palubinskas** (p. 155)
*Circle*, 2010
oil on panel
16 x 15 in.
renatapalubinskas.com

 **Joe Sorren** (pp. 168, 169)
*Given the Difference Between No.1 and No.2*, 2010
oil on canvas
18 x 60 in.
joesorren.com

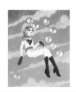

**Tara McPherson** (p. 171)
*Laughing Through the Chaos of it All*, 2008
oil
20 x 24 in.
taramcpherson.com

**Florencia Zavala (Studio Number One)** (pp. 184, 185)
*Untitled*, 2010
digital
22 x 9 in.
studionumber-one.com

**Catalina Estrada** (p. 199)
*Clown Birds*, 2010
digital
11 x 9 in.
catalinaestrada.com

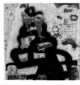

**Erik Foss** (p. 213)
*American Tale*, 2010
mixed media on canvas
8 x 10 in.
erikfoss.org

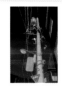

**Andrew Bell** (p. 173)
*Expedition*, 2010
Digital
25 x 38 in.
creaturesinmyhead.com

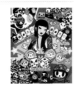

**tokidoki** (p. 187)
*Untitled*, 2009
digital
9 x 11 in.
tokidoki.it

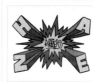

**Eric Haze** (p. 201)
*Untitled*, 2008
digital
14 x 10 in.
interhaze.com

**Nathan Fox** (p. 215)
*Fatherhood*, 2010
pen and ink
6 x 10 in.
foxnathan.com

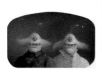

**Travis Louie** (p. 175)
*The Flower Sisters*, 2010
acrylic on board
24 x 16 in.
travislouie.com

**BLOKT** (p. 189)
*Riot Afterparty*, 2010
mixed media
12 x 9 in.
bloktblog.blogspot.com

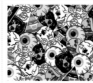

**Mishka** (p. 203)
*Untitled*, 2010
digital
9 x 11 in.
mishkanyc.com

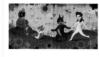

**Gary Baseman** (pp. 216, 217)
*Garden of Enlightenment*, 2010
oil on board
26 x 13 in.
garybaseman.com

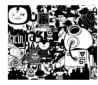

**UNKL** (p. 177)
*Untitled*, 2009
digital
9 x 11 in.
unklbrand.com

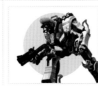

**Edatron** (p. 191)
*Untitled*, 2009
digital
9 x 11 in.
emorobo.com

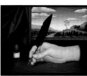

**Isabel Samaras** (p. 205)
*Redivivus (The Poet)*, 2006
oil on wood
12 x 9 in.
devilbabe.com

**Jim Houser** (p. 219)
*The Jargon of Criminals*, 2010
acrylic, collage, and mixed media on canvas
35.5 x 25 x 3 in.
jimhouser.com

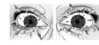

**UPSO** (pp. 178, 179)
*Untitled*, 2009
digital
9 x 9 in.
upso.org

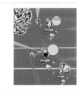

**Dalek** (p. 193)
*Untitled*, 2009
digital
9 x 10 in.
dalekart.com

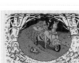

**ROSTARR** (p. 207)
*Odyssey for Oro Puro*, 2004
acrylic, ink, and aerosol enamel on canvas
64 x 111 in.
rostarr.com

**Julie West** (p. 181)
*Wilted*, 2010
digital
9 x 11 in.
juliewest.com

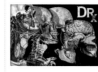

**Darren Romanelli** (p. 195)
*DRx Cranial Explosion*, 2008
mixed media
18 x 12 in.
drromanelli.com

**Jeremy Fish** (p. 209)
*The Ambush*, 2009
screen print
22 x 34 in.
sillypinkbunnies.com

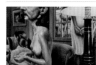

**Eric White** (p. 183)
*On the Air*, 2008
oil on canvas
48 x 72 in.
ewhite.com

**eBoy** (p. 197)
*Baltimore*, 2010
digital
13 x 17 in.
eboy.com

**David Flores** (p. 211)
*Lee Lee*, 2008
digital
6 x 11 in.
davidfloresart.com